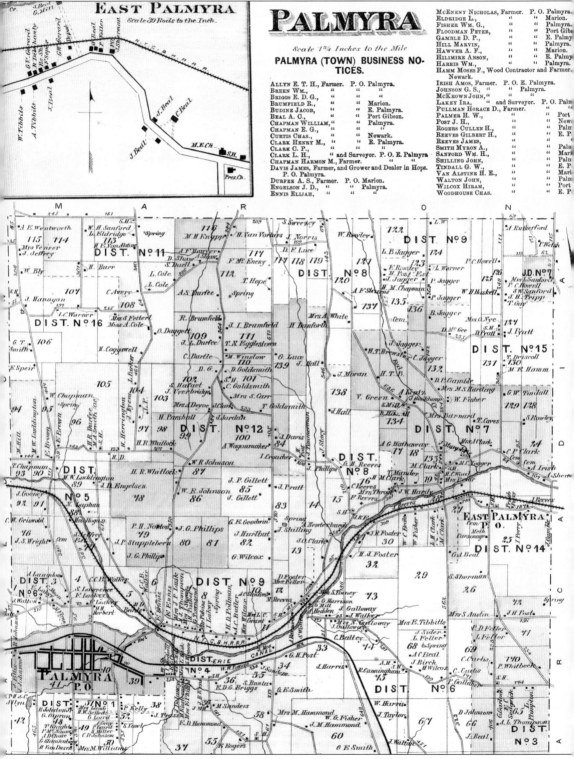

This 1864 map of Palmyra is from the F. W. Beers Company atlas.

Bonnie J. Hays

Copyright © 2004 by Bonnie J. Hays
ISBN 0-7385-3589-3

First published 2004

Published by Arcadia Publishing
Charleston SC, Chicago IL, Portsmouth NH, San Francisco CA

Printed in Great Britain

Library of Congress Catalog Card Number: 2004102494

For all general information, contact Arcadia Publishing:
Telephone 843-853-2070
Fax 843-853-0044
E-mail sales@arcadiapublishing.com
For customer service and orders:
Toll-free 1-888-313-2665

Visit us on the Internet at www.arcadiapublishing.com

On the cover: This *c.* 1885 photograph shows the Tripp Millinery Store, located on the south side of East Main Street in the block east of Fayette Street. The man on the bicycle is O. J. Garlock, before his successful days. Near the Tripp Millinery Store, the first reading room was funded by Pliny T. Sexton. The stairs and storefront are still visible today.

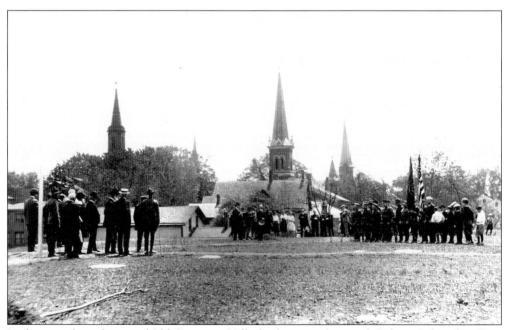

In this view from the top of Old Cemetery Hill, the four steeples watch Palmyra's founder, Gen. John Swift, receive a well-deserved monument and proper epitaph from his community.

Contents

Acknowledgments		6
Introduction		7
1.	Breaking into a New Frontier	11
2.	The Burned-Over District	25
3.	Education, Always Important	43
4.	From the Erie Canal to Trains	57
5.	The People and Their Influence	71
6.	Early Industry and Business	87
7.	There Was Always a Cause	101
8.	The Importance of Organizations	111
9.	The "Queen" Still Has Her Majesty	121

Acknowledgments

This is for all the people of Historic Palmyra who have preserved the buildings, artifacts, and collections for all to enjoy. Because of your efforts we have saved our "Queen" and all of her history. All photographs are from the collection of Historic Palmyra with the exception of three that were lent by private collectors. Thank you.

INTRODUCTION

This section of New York State, called Montgomery County in the early days, included all the lands west, north, and south of Schoharie as part of the Massachusetts Colony. In 1786, the Continental Congress determined that this section would become part of New York State. Land investors Nathaniel Gorham and Oliver Phelps purchased six million acres of this land known as the Genesee Country. Phelps was to arrange land agreements with a party of Seneca chiefs led by Chief Red Jacket and Chief Corn Planter while Gorham worked with New York State authorities on the Massachusetts and New York State borders.

Palmyra's founder, John Swift, joined the American War of Independence at the age of 15, receiving a captain's commission after eight years of service. Swift decided to make a home in the Wyoming Valley on the border between Pennsylvania and New York along the Susquehanna River. Almost 1,500 Connecticut families followed Swift to the Wyoming area already claimed by Tory rangers who disputed the new Connecticut settlement. The Pennemite Wars ensued, resulting in the Wyoming massacre of many settlers. Swift was shot in the neck as he was setting fire to a Pennemite blockhouse. Taken to a safe location for medical attention, he recovered and was appointed to search elsewhere for a new home for the surviving Connecticut families.

In 1789, Swift looked to the Phelps Gorham Purchase Company for land, agreeing to purchase Township 12, Ranges 2 and 3. John Jenkins, a surveyor with Phelps and Gorham, joined Swift in this venture. Four men—Earl, Baker, Rawson, and Harris—were hired by Jenkins to build a log structure and to survey lots. While Swift searched for adventuresome settlers to buy land to pay for his sizeable investment, Jenkins and the others continued to lay out lots. One still night as Jenkins and the others slept around the smoldering fire, a small band of Tuscarora Indians surrounded the compound, firing shots at the unsuspecting men. Baker was killed and Earl severely injured. Jenkins, Rawson, and Harris leaped into action, pursued the attackers, and retrieved a tomahawk and some guns the Indians left behind. The survivors buried Baker and took Earl for medical help in Geneva, where the alarm of attack was sounded. Swift had built the first store and ashery near Mill Creek, and Jenkins had built a tavern at the base of a hill about two miles south of the village. Discouraged by the attack, Jenkins sold his land to Swift and left the area. The original Connecticut group also decided against a Genesee Country settlement, forcing Swift to seek settlers from Rhode Island, Massachusetts, Connecticut, and Long Island.

Finding new settlers was a difficult task, and Swift's land debt was past due. A Rhode Island family led by Gideon Durfee paid Swift 20¢ an acre in "coin" for 1,600 acres. That payment enabled Swift to meet the debt to Phelps and Gorham and receive the warranty land deed. By 1793, Palmyra had begun to grow. Roads were being cleared, and a store was opened. By 1796, Main Street had been extended eastward and westward and Canandaigua Street, leading southward, had become a plank road. Captain Williamson requested a number of men to help build a road to Lake Ontario. Only the hardiest horse or oxen cart could travel over these roads. Although the early days were fraught with hardship and death, many settlers traveled back home and brought their families to this new frontier. Palmyra was called Swift's Town, Swift's Landing, and Tolland. At the first town meeting in 1796, John Swift was named supervisor. With the idea of finding an official and more likeable name for the new community, another town meeting was held in 1797. Daniel Sawyer, Swift's brother-in-law, who was studying ancient history and engaged to a local school teacher, declared the name should be Palmyra. Sawyer reasoned that his beloved Dosha should have her own Palmyra, as did Queen Zenobia of Syria.

Swift provided land for the first union church, which served as the town meeting hall, followed by the first school, which gave way to the first cemetery. In 1812, Swift was promoted from captain to brigadier general and went off to fight in the War of 1812. While capturing a picket guard at Fort Erie, he was shot in the chest and later died of his wounds. The citizens of Palmyra exhumed his body and brought it home to rest with a meager stone memorial on Old Cemetery Hill. In 1923, a monument honoring Swift was placed at his grave by the American Legion James R. Hickey Post No. 120.

Forward thinking and disciplined, Palmyra's community withstood the exodus of many of its people to Ohio, Illinois, and Michigan, as well as the cities of Rochester and Buffalo. Prior to 1820, Palmyra's population exceeded Rochester's by almost 1,600. Although many left, others who saw the Palmyra vision arrived to fill the vacancy. The economy of Palmyra was based on agriculture, retail business, and manufacturing. Palmyra, being a central location for transport on the Erie Canal, saw men like Calvin Seeley, James Galloway, Pliny Sexton, and William Southwick build warehouses and businesses on Market and Canal Streets to accommodate travelers. Palmyra was established 36 years prior to the official 1825 Erie Canal opening, whereas communities like Fairport and Rochester began as a result of the Erie Canal. From the 1820s to the 1850s, Palmyra bustled with wagons carrying the crates and barrels that always lined Main Street, waiting to be loaded onto barges. Franklin Lakey had the largest warehouse business, slaughterhouse, and distilleries in the area. He hired hundreds of men who worked night and day to keep the canal barges full and moving. The Erie Canal flourished and underwent two enlargements, until finally in 1910, a new canal was dug to replace the old Erie.

Township 12, Range 2 was Palmyra, and Range 3 is today's Macedon. Both were part of Ontario County until 1823, when Wayne County was formed. Sometime between 1819 and 1823, the town of Macedon separated from the town of Palmyra.

Because it was a hotbed of religious activity, the area became known as the Burned-Over District. Lemuel Durfee supplied a Quaker meetinghouse on the north corner of his property. In 1803, the Quakers broke into two branches: the Orthodox and the Hicksites, the latter taking their name from preacher Elias Hicks. The Orthodox Quaker Church eventually moved to Macedon Center, while the Hicksites remained on the Durfee farm until their building burned.

The first organized church was Congregational, and in 1793, the Congregational Church took on the Presbyterian style of worship under the Geneva Presbytery. It was incorporated as a Presbyterian Church in 1797. Gideon Durfee and Humphrey Sherman gave land, and Oliver Clark and Sherman helped fund the church building after much discussion about who would sit on which side of the church. Humphrey said there were few men worthy of sitting in church and wished his side to be for women. In 1807, the first formal church building was begun. Although not completed, the building was dedicated in 1811, with still an occasional visit from a stray animal or a farmer's crops drying on the open rafters.

Between 1832 and 1872, one by one, the four churches were built at the intersection of Main and Canandaigua Streets. Built first was the Western Presbyterian, followed by the First United Methodist, First Baptist, and Zion Episcopal. *Ripley's Believe It or Not* of 1938 notes this intersection to be the only one in America to have a church on each corner.

Unknown to Palmyra was the part it would play in the religious sector when a young man named Joseph Smith Jr. arrived in Palmyra in 1816 with his father, mother, and eight siblings. Smith was searching for a religion that would satisfy his faith and belief. His search began in the Presbyterian Church in 1821, followed by his first proclaimed vision, in which he received the word about his destiny. In 1823, at the age of 16, Smith said the angel Moroni came to him, directing him on the path toward finding a lost book. As is said, the angel Moroni gave him instructions to find this lost book in the form of golden plates. Smith translated the golden plates, which were printed by Palmyra's E. B. Grandin and financed by Martin Harris. Finally, 5,000 copies of the first *Book of Mormon* were completed in 1830. Thus, the Church of Jesus Christ of Latter-day Saints was born in America. Smith and his brother Hyrum (Hiram) traveled west, unfortunately, meeting death along the way. Buried on Old Cemetery Hill in Palmyra is Alvin Smith, who died at an early age before he could witness the results of his brother's revelations. Sites such as Hill Cumorah, the Sacred Grove, and the Smith log and frame homes are revered by the church and its followers.

In the 1840s, in a cabin on Hydesville Road just outside of eastern Palmyra, the Fox sisters communicated to a spirit through rapping, or tapping, beginning the doctrine of spiritualism. Although the sisters have long since gone, evidence of their famed rapping has found a home in Lillydale, near Buffalo. In Port Gibson just east of Palmyra in Ontario County, the local Millerites met, resulting in today's East Palmyra Seventh Day Adventist Church. The local Catholic church was organized in 1849, followed by the Dutch Reformed, Church of God, Assembly of God, Christian Science, and others.

Many famous people hailed from or got their start in Palmyra between 1800 and the mid-1900s, putting the town on maps all over the world. The list begins with famed photographer George Elton, winner of eight World Gold Medals; Henry Wells, cofounder of Wells Fargo and American Express; Leonard Jerome and his wife, Clarissa Hall Jerome, grandparents to Sir Winston Churchill; professional weavers James Van Ness and Ira Hadsell; E. J. "Uncle Joe" Read, artist and teacher; Increase Latham, America's first official weatherman; Sens. F. W. Griffith and Henry Griffith; Rev. Horace Eaton and Pliny Sexton, abolitionists; John M. Jones, inventor and manufacturer; Olin J. Garlock, inventor and industrialist; Pliny T. Sexton, banker and chancellor of the State University of New York; and Rear Adm. William T. Sampson, hero in the Spanish-American War of 1898.

Palmyra's military history shows strong commitment for America's pursuit of freedoms beginning with the War of 1812. The Civil War saw one of the largest recruitments in Wayne County. The Mexican War, the Spanish-American War, World War I, World War II, the Korean War, the Vietnam War, Desert Storm, and the war in Iraq have called upon Palmyra's citizens, and they have answered without hesitation. A true portrait of the community's convictions is evident in its military record.

No longer do large warehouses line the Erie Canal. Gone are the livery yards with animals waiting to be sold or slaughtered, the buzz of the lumber mill, and the soot of the coal yard. Main Street no longer ends at Canal Street but continues toward Newark and is now state Route 31. The 1858 aqueduct towpath is now a trail leading to the newly restored Aldrich Change Bridge, a Whipple-style bridge. The Main Street area has remained original despite the urban renewal changes of the 1970s. Today, there is a new port of Palmyra, with pleasure boats rather than canal barges and bicycles instead of towpath mules. Although modernizations have occurred, the original William Phelps General Store and the quaint, canal-town streets still exist.

People with names such as Swift, Harwood, Spear, Johnson, Foster, Comstock, Hathaway, Jessup, Cuyler, Palmer, Sherman, Wilcox, Goldsmith, Sexton, Chase, White, Robinson, Holmes, and Rogers and many others of hearty stock with military discipline, business savvy,

legal knowledge, and American pride were among the first families of Palmyra. As America's founders did in 1776, Palmyra's founders built a community that will grow through changes and remain as it was originally intended: a community built by people for people. These pages show the peoples' names and faces and tell their stories. Like any story, this one starts just where it should—at the beginning.

One

BREAKING INTO A NEW FRONTIER

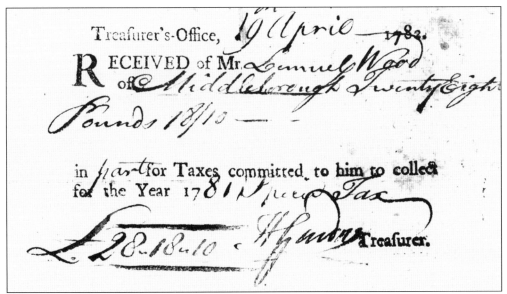

This document dates from 1781, before any settlement occurred in Palmyra. It is a tax bill for 28 pounds, issued to Lemuel Ward, a native of Wales who emigrated to Vermont. The tax was collected at the treasurer's office on April 19, 1782. Daniel Ward, son of Lemuel, moved to Palmyra with his family and lived on Johnson Street. He worked in the Jenner Furniture Factory as a turner. He married, raised children, and died in Palmyra.

The founder of Palmyra, Revolutionary War veteran Gen. John Swift, died of a wound to the chest during the War of 1812. He was shot while capturing the picket guard at Fort Erie in 1814. One of the guards shouted, "Who is General Swift?" and when Swift proudly replied, "I am," the shot was fired. The New York State Legislature ordered that Swift's son be given his father's sword and that Swift's full-length portrait be hung in city hall in New York City. This photograph of his portrait dates from 1885.

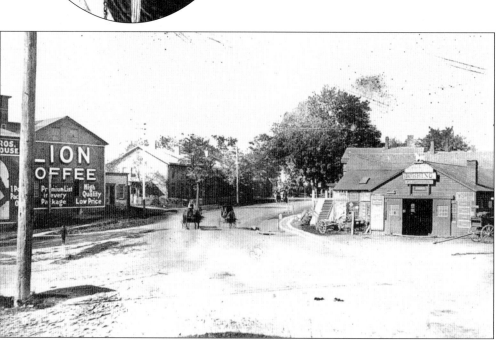

After the 1789 Indian attack on his compound, Swift built a better structure on Mill Brook near the future East Main and Canal Streets junction where the Railroad Avenue bridge crossed the Erie Canal. Swift's building is long since gone in this 1899 view looking west from the Railroad Avenue Bridge. Shown are a carriage shop with a jobbing sign and the old Galloway Malt House (left) advertising coffee.

This Indenture of agreement made and Executed this twenty sixth day of April in the year one thousand seven Hundred and Ninety nine Between John Swift of the Town of Palmyra County of Ontario State of New York of the first part and Enoch Sanders of the same Place of the Second part Witnesseth ———

the said party of the first part doth agree that the Consideration of five Dollars to him in hand paid to Execute a good Deed in Law to the said party of the second part for fifty acres of land in Township No. twelve Second Range in Philps and Gorham Purches Begining on the South Line of said Town where the New Cannandargua Road Crosses said Line thence North thirty two Rods thence East one Hundred and thirty Rods thence South thirty two Rods thence West one Hundred and thirty Rods to the Place of begining or so much of the fifty acres as the party of the second part shall pay for at the Rate of four Dollars pr acre and the Intrust from the first Day of March last past by the first Day of January one thousand Eight Hundred and one laying Next to the Cannandargua Road ———

2d the said party of the second part doth agree to pay one Hundred Dollars by the first Day of January Next with Intrust from the first Day of March Last and one Hundred Dollars with intrust from the first Day of march Last by the first Day of January Eighteen Hundred and one — in Testimony of the above agreement the parties have hereunto Interchangable set their Hands and Seals year and day above Written

Samuel Millet John Swift

Enoch Saunders came to Palmyra from Connecticut and worked for John Swift. This 1791 indenture shows he bought 50 acres of land from Swift for $205. He then brought back a wife, Abigail, from Connecticut, and the couple had four children. One son, Orlando Saunders, stayed on the homestead, married Belinda White, and also raised four sons. Three generations lived on the same land for 100 years, farming, hunting, and tanning.

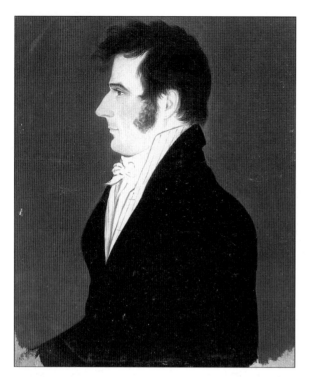

In Palmyra's history, there are three Lemuel Durfees. The first Lemuel Durfee to settle here was born in 1759, the son of Gideon Durfee. He and his wife, Prudence, had 11 children. Durfee arrived with his family in 1794, becoming the last of the Durfee family to move to Palmyra. Before his arrival, Ruth and Stephen Durfee came, and later, Ruth Durfee and David Wilcox had the first wedding in Palmyra. This picture is part of a set of wooden paintings *c.* 1790.

A handwritten sign on the back of this woman's picture says "Patty," which in this case is believed to be short for Prudence. The picture is part of a set of wooden paintings. Members of the Durfee family lived on their farm property for over 100 years. Lorenzo Warner and the remaining Durfees sold the entire estate in the early 1900s.

In 1790, brothers Gideon and Edward Durfee were the first members of their family to settle in this western frontier. Gideon Durfee went back to Rhode Island to share stories of prosperity. He returned to Palmyra in 1791 with Isaac Springer to prepare for the entire Durfee family. He opened a tavern and reportedly entertained a royal visitor as an overnight guest. Prince Louie Phillipe of France, in hiding after his father was dethroned, is said to have stopped at Durfee's tavern for refreshment and sleep in 1796.

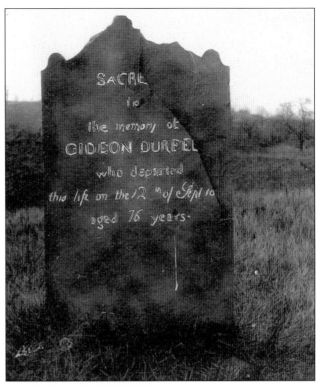

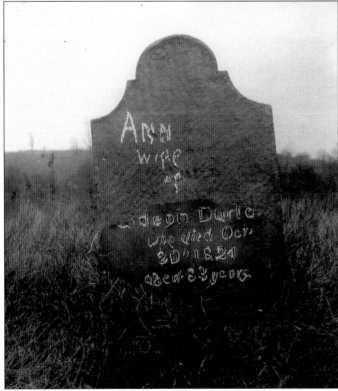

Anna Durfee's stone reads, "Sacred to Anna widow of Gideon Durfee who died Oct. 20th, 1821 aged 83 years." The first homegrown apples in Palmyra were raised by the Durfee family, and the Osband pear is credited to Weaver Osband, who grew a pear seedling that his father-in-law, Pardon Durfee, had given him. Maria Durfee is said to have been the first female child born in Palmyra.

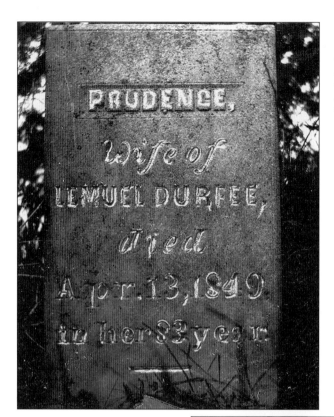

Prudence Durfee raised all of her 11 children in the new wilderness. Her grave marker reads, "Prudence, wife of Lemuel Durfee, died April 13, 1849 in her 83 year."

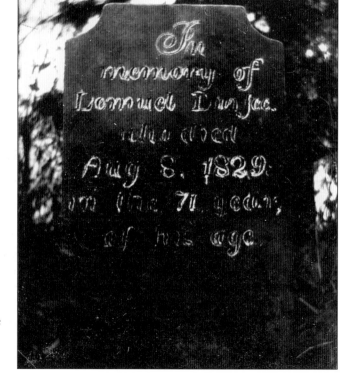

Lemuel Durfee's stone reads, "In memory of Lemuel Durfee who died Aug. 8, 1829 in the 71 year of his age." The tombstones reflect the long life of some of the earliest members of this pioneer family. Pictured c. 1940, these stones are now so old that weather and time have made them also a memory.

After Lemuel Durfee II died in 1855 at the age of 70, his two bachelor sons built a home. Isaac and Lemuel Durfee III built this magnificent house of pressed red brick, with an interior of mostly fine wood harvested from their farm. Lemuel III died before the house was finished, and Isaac died shortly after it was completed. When this 1880 photograph was taken, the family must have been visiting.

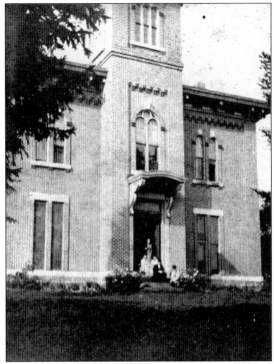

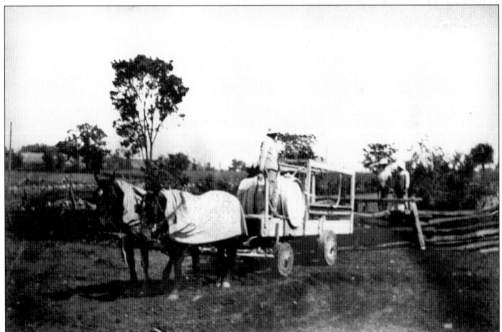

This 1860s view of the Durfee's solid wooden-wheeled wagon carrying a barrel is a reminder of the tragedy that befell Emory Durfee's wife. On the way home in a wagon, she stopped at the top of a hill to let the hired girl get out with the baby. As she was heading down the hill in the wagon, a strap broke, frightening the horses. Her hair became caught and she was dragged, resulting in her death shortly after the wagon stopped.

> ONTARIO COUNTY, ss—
>
> Edward Durfee a freeholder and inhabitant of the town of Palmyra in said county, being duly sworn, deposeth and saith, that he is well acquainted with the farm of *Asa R. Swift*, situate in the town of Palmyra, both before and since a part of the Erie Canal has been made through the same, and from the best judgment and estimation this deponent can form respecting the damages done to the said farm, relation being had as well to the advantages to be derived from the said Canal in its course through said farm, as to the inconveniences resulting from the occupation of land for the purposes of said Canal, as the detaching about ten acres, from all convenient access from the rest, do estimate and adjudge that the sum of six hundred dollars will not more than repair the damages which have depreciated the value of said farm for the causes aforesaid.
>
> Sworn before me, this fourteen th day of December 1821.
>
> Edward Durfee
>
> James White Counselor of Ontario County —

Shown is Edward Durfee's sworn affidavit to the Ontario County Court, dated 1821. It describes damage to the land of Asa Swift, son of John Swift, that resulted from digging the Erie Canal. Durfee appraised the damage, stating that he knew the land before and after the Erie Canal. He assessed the damage and inconvenience at $600 for 10 acres of land. James White of the court of Ontario County signed this paper as witness or notary.

Oliver Durfee was the president of the village from 1885 to 1886. A stately looking young man, he was a businessman who, with a William Southwick, purchased land on the banks of the old Erie Canal near Division Street in 1870. In the 1880s, Southwick suffered an irreversible stroke. The property ended up as a coal yard, which was sold and enlarged a number of times. The photograph dates from 1885.

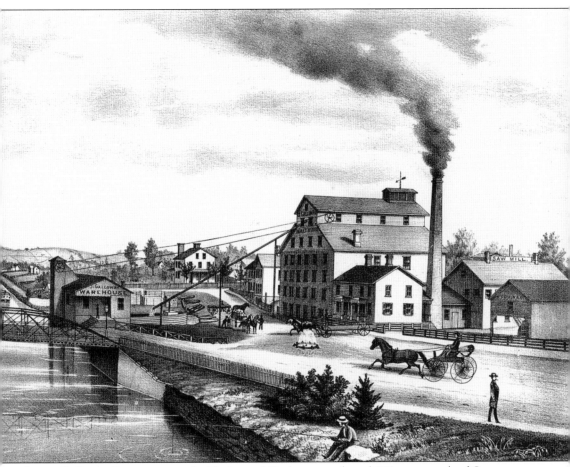

James Galloway Sr., a surveyor for Phelps and Gorham, purchased 100 acres south of Ganargua Creek on what is Hogback Hill Road in 1791. He built the first mill in Palmyra by damming the creek. In 1865, James Galloway Jr. purchased the property that became the Galloway Malt House. Pictured in this 1865 view of the malt house, originally the site of a tannery built by a George Palmer and later run by a Henry Jessup, is the intersection of Main and Canal Streets, ending at the Erie Canal and crossing north on the Railroad Avenue Bridge. Marked by a large monument, the Galloway family cemetery stands on a grassy knoll overlooking Vault Road.

Julia Emilia Galloway was a descendant of the first Galloway family. She married Milo Yeoman, a member of another early pioneer family in this area. This 1880 photograph shows her as a young woman. (Photograph by Vail's Photographic and Fine Art Gallery of Palmyra.)

Three young women wear high-necked dresses, the proper style in those days of the 1880s. From left to right are Emma Crane (Sweezey), Julia Emilia Galloway (Yeoman), and Emily Hickey (Beach). (Photograph by the D. N. Parks Photographic Gallery of Marion.)

James Sutton Galloway was a namesake of James Galloway Sr. and James Galloway Jr. This photograph was taken c. 1880 in Michigan, indicating that this portion of the Galloway family, like many other early settlers and their children, sought a home in Michigan. (Photograph by Andrew & Ives of Hillsdale, Michigan.)

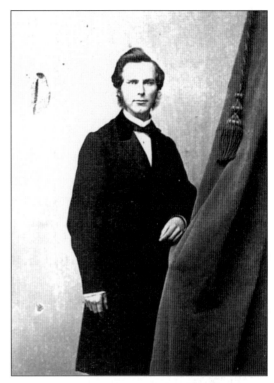

Quite a traveler, young Milo Yeoman posed for many photographs. This c. 1880 portrait was from a studio in New York City. Yeoman married Julia Emilia Galloway, whose father, Milo Galloway Sr., owned and operated the *Comptroller*, a boat on the Erie Canal in 1835.

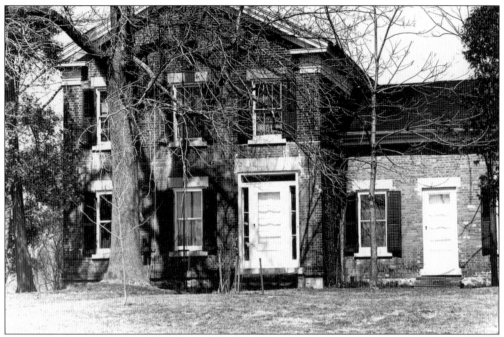

The Galloway Homestead was established in 1793 on Galloway Road near East Palmyra. The Thomas Galloway House, pictured in 1930, is located on the south side of the canal. Today, it is a bed-and-breakfast establishment bearing the same name.

The old Galloway barns were located in back of the Galloway Homestead, which was established in 1793. The Galloway family was the first to have a gristmill on Ganargua Creek, which dammed up the creek. Some members of the Galloway family contracted to dig some 60 rods of the old Erie Canal. They used oxen and a scraper to move the dirt and straighten out the water trough.

Pictured in 1940, this beautiful house was built c. 1812 by Peleg Holmes. His daughter Harriet married Gen. Thomas Rogers, and Holmes gave the house to the couple. Holmes owned a large piece of land north of and all the way to the end of East Main Street. As a road was needed along the Erie Canal, he gave land for Canal Street. Holmes Street is still in existence, and Prospect Hill, once owned by Peleg Holmes, was formerly called Holmes Mountain.

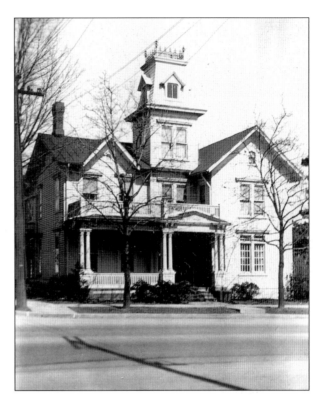

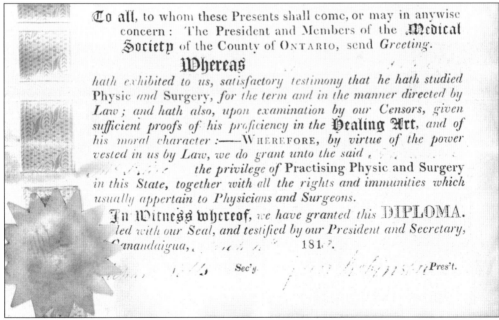

This original certificate was given to Dr. Alexander McIntire as he was being admitted to the Ontario County Medical Society in 1810. Dr. Gains Robinson was the president of society. Along with Robinson and McIntire, other early Palmyra doctors included Durfee Chase, Lemuel Durfee, Azel Ainsworth, John Lakey, Donald McPherson, Almon Pratt, and Harriet Adams.

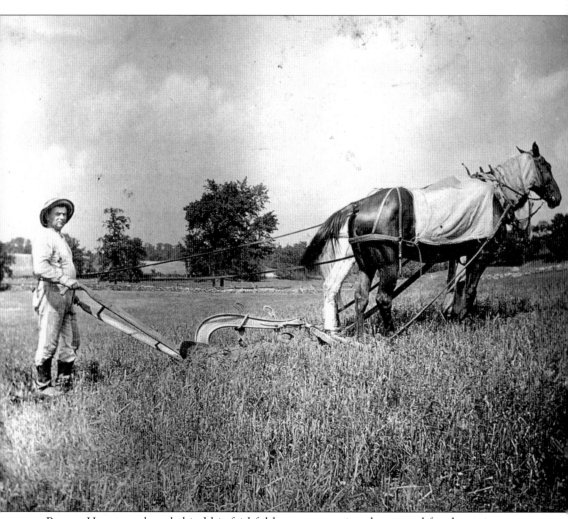

Barney Hanagan plows behind his faithful horses, preparing the ground for the spring crop c. 1890. Unusual for its day, the photograph has exquisite lighting and captures the natural look and movement of the subject. (Photograph by George Elton, courtesy of a private collection.)

Two
THE BURNED-OVER DISTRICT

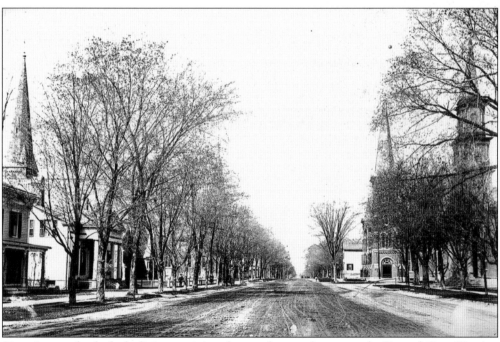

Since it was a hotbed of religious activity, the area became known as the Burned-Over District. This 1895 view looking westward on Main Street shows the steeples of the four churches mentioned in *Ripley's Believe It or Not* of 1938. From left to right are the Zion Episcopal Church, the Baptist church, the Methodist church, and the Western Presbyterian Church. East of the Zion Episcopal Church are two houses that have long since gone.

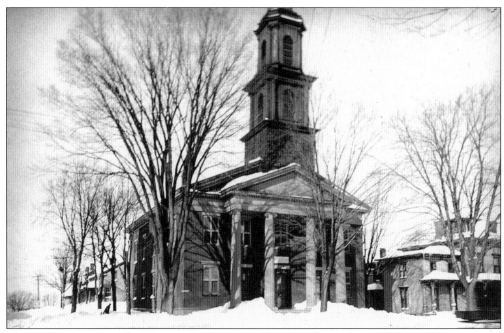

The main structure of the Western Presbyterian Church still stands as it did in 1833, except for some additions, the removal of the town clock, and a new steeple. The church was dedicated in 1834 during the term of Reverend Whepley. Construction began in 1832 with Gen. Thomas Rogers removing the first wheelbarrow of dirt. This is the oldest original church building in Palmyra still owned by the original faith and used as a church today. This photograph dates from c. 1905. (Courtesy of O. J. Garlock collection.)

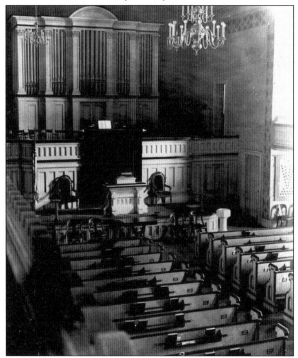

Pictured are the altar and the magnificent organ of the Western Presbyterian Church. Standing before this altar in April 1849, a young couple took their wedding vows. As they left the church, riding the short distance to Canal Street, newlyweds Leonard and Clarissa Hall Jerome started their successful life together, having no idea of the impact their union would one day have on the world. They would become grandparents to Sir Winston Churchill.

Shown in 1885 is Anna Eaton, wife of Rev. Horace Eaton, D.D. The reverend was the Western Presbyterian Church minister from 1849 to 1879. A dedicated and passionate activist, he fought for abolition and temperance. His powerful orations attracted or disenchanted many members of his own congregation. Anna Eaton wrote her husband's memoirs, telling in graphic detail of his encounters in Congress.

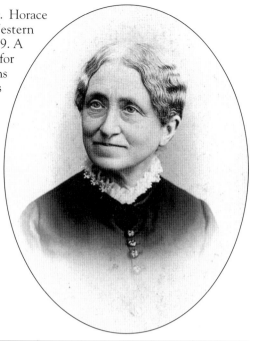

Anna Eaton is pictured on a rainy day at the Wayne County Fairgrounds with Rev. Angus Hugh Cameron, minister of the Western Presbyterian Church. Rain was typical for the three-day Wayne County Fair, held in the fall of each year.

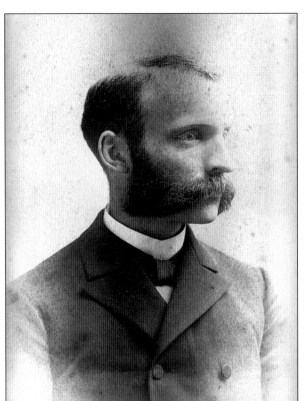

Rev. Warren Langdon was the minister of the Western Presbyterian Church from 1879 until 1887, directly after Rev. Horace Eaton. Langdon was replaced by Rev. Herbert D. Cone. (Photograph by George Elton.)

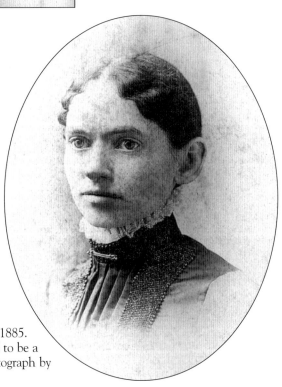

The wife of Rev. Warren Langdon poses *c.* 1885. A preacher's wife has always been required to be a major part of her husband's mission. (Photograph by George Elton.)

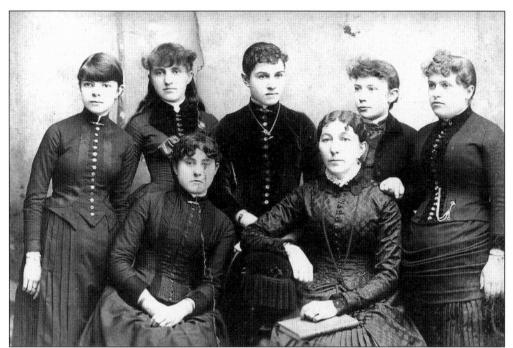

Six girls in high-collared dresses look appropriate for a Sunday school class *c.* 1895. From left to right are the following: (first row) Nina Crandall and Mrs. Howe, the Sunday school teacher; (second row) Jennie Ward, Katie Story, Martha Harmon, Lucy Davis, and Gail ?. (Photograph by A. Hopkins of Palmyra.)

Decked out in fur and fancy hats, from left to right, are Marcia ?, an unidentified person, and Charles ?. They are standing on the front stairs of the rectory of one of the churches. The picture was taken on a chilly fall day in November 1900.

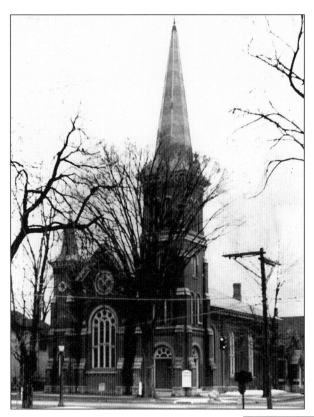

The First Methodist Church, pictured in 1930, began as the Methodist Episcopal Church in 1797, meeting in homes. This small group was in the Genesee Conference, Ontario circuit. Later, this conference served 2,500 members from 15 churches. A circuit preacher was assigned to make the rounds of his specific churches. After meeting in temporary locations, the Methodist Episcopal group chartered and purchased property at the corner of Vienna and Johnson Streets in 1822. In 1847, the church was moved to Cuyler Street. In 1867, the parishioners built this new larger church on the northeast corner of the Main Street intersection.

The First Baptist Church, pictured in 1930, began and met at Lemuel Spear's home in 1800. In 1808, a church was built on Walworth Road just north of Quaker Road between Macedon and Palmyra. In 1832, the Baptists of Palmyra, desiring their own church, separated from the Macedon group and met in the old church house on Cemetery Hill until it burned down in 1838. They then built a church, which lasted 30 years. That building was replaced with a new church that still stands on the southwest corner of the intersection of Main and Canandaigua Streets.

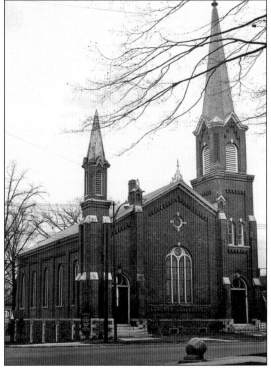

The Palmyra Zion Episcopal Church began here in 1822. By 1827, the cornerstone was laid for a church building. Prior to completion of that building, in 1828, the Zion Episcopal Church became an organized parish. In February 1829, the church was dedicated by Rt. Rev. Bishop Hobart. George D. Gillespie, the rector from 1851 to 1861, became the bishop of Western Michigan. The wooden structure served the church until a new church was built in 1872. Pictured c. 1895, the church stands on the southeast corner of Main and Canandaigua Streets, the former site of Palmyra's first brick building.

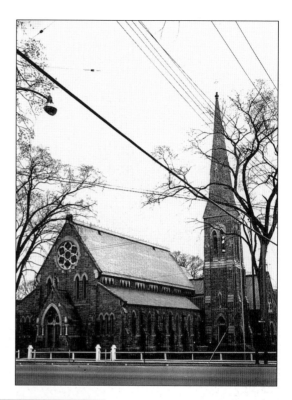

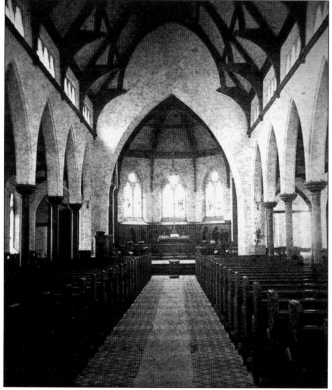

The unique interior of the Zion Episcopal Church is pictured shortly after the building was constructed in 1875. Note the pillars in the center of the pews supporting the wood-covered cathedral ceiling. The lettering over the sanctuary arch and on the altar, as well as the chapel's wooden cross, are reminders of Rev. John Webster, who was greatly loved and respected. Webster resigned in 1884 and went to another church, where he served until his death in 1887.

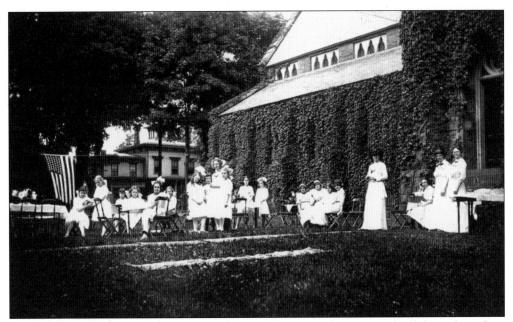

Sunday school has always been a necessary part of church study. Here, girls all dressed in white have a picnic or party outside the Sunday school class *c.* 1890. It could be a confirmation day, as even the women are in white dresses. The ivy climbing the side of the east wall of the Zion Episcopal Church has given way to a very functional new fellowship hall with classrooms, a kitchen, and church offices.

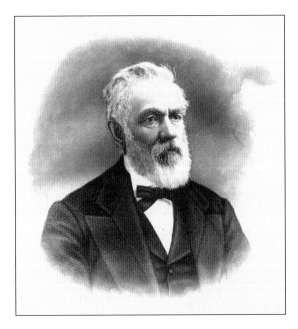

The Zion Episcopal Church is made of Medina sandstone and has a 125-foot steeple. The steeple was given by George W. Cuyler, pictured here, in memory of his three children. During construction, two trips were made each day to get the special stones needed to line the steeple: to the Newton Farm on the outskirts of the village and south to Manchester and the Salt Farm. Cuyler also traveled a great distance to get the new church bell.

St. Anne's Catholic Church was founded in 1849. Before its founding, the faithful traveled to Williamson or Canandaigua to go to Mass. The old academy across from Cemetery Hill was purchased and used until 1859. The new St. Anne's Church was built and opened in 1860 and completed in 1870, with a priest's house, dedicated by Rt. Rev. Bernard J. McQuaid. The house was moved to the end of Church Street, and a new one was built in 1920.

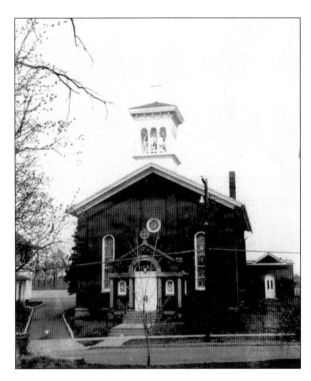

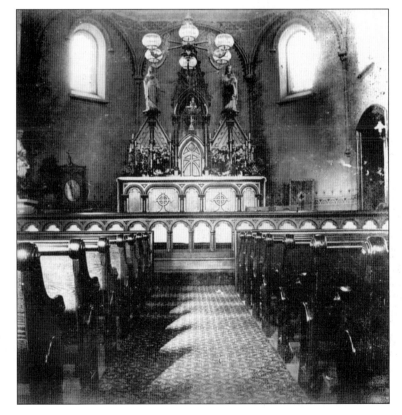

This photograph shows the interior of St. Anne's Catholic Church between 1898 and 1903. In 1942, a broken gas line resulted in a huge explosion that left the main church heavily damaged. Repairs took more than eight months, during which time the new hall on the east side was used for Mass. By 1943, the new interior had been completed and the main church reopened. (Courtesy of O. J. Garlock collection.)

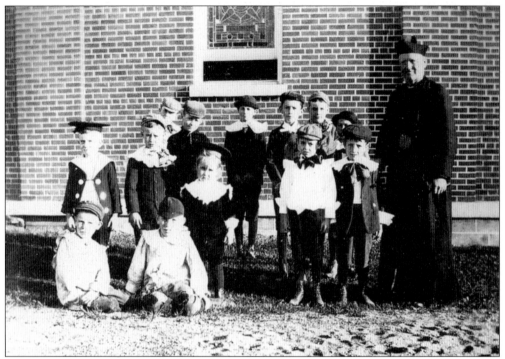

This St. Anne's Sunday school class is made up of boys about four to six years of age. A priest stands by the orderly group. This moment in 1898 is one of many community scenes that were saved because of O. J. Garlock's photographic hobby.

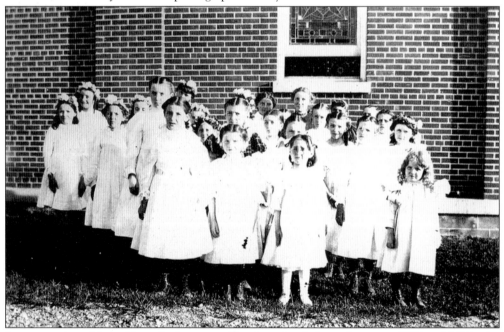

It appears that girls and boys had separate Sunday school classes between 1898 and 1903, the period of time in which the O. J. Garlock collection of photographs was taken. This girls' class stands outside the window of the St. Anne's Catholic Church.

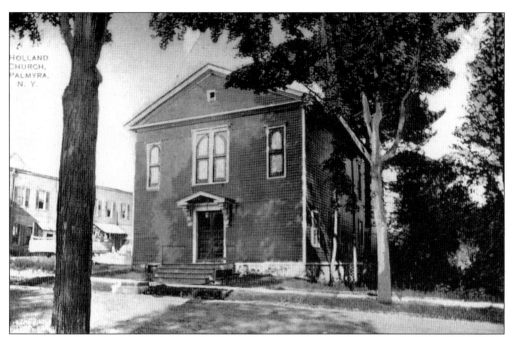

The Dutch Reformed Church organized in 1887 with 34 members. Services were held in the Western Presbyterian Church until 1890, when P. T. Sexton purchased the old Methodist church, pictured here c. 1895. The old church served as the home of the Dutch Reformed parishioners while they awaited the completion of their new building on Canandaigua Street.

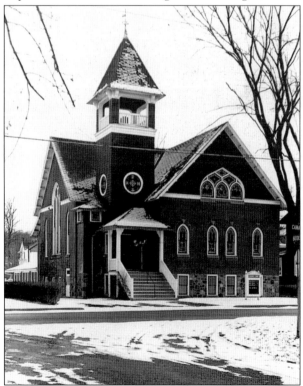

The new Palmyra Reformed Church was built in 1900. This building still serves as a church today, with a fellowship hall built on the back. The church and the parsonage were constructed for about $10,000, with much hard work contributed by the parishioners.

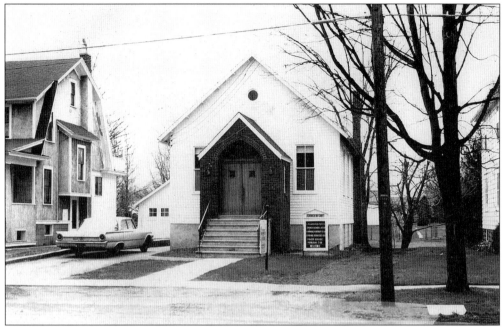

The Church of God church, pictured in the 1950s, was located on Canandaigua Street just south of St. Anne's School. It was very small in structure but large in volunteers. Charlotte Birdsall gave money for the land, and the parishioners volunteered to build the church. The building was sold in the 1980s; today, it is a private residence.

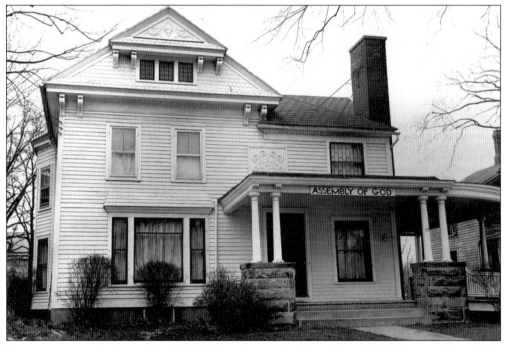

For many years, the Assembly of God Church met in the residential building on West Main Street, the third building west of the First Methodist Church. Eventually, the group built its own church on the corner of Vienna Road and Route 31. This picture dates from 1955.

A statue of Joseph Smith, translator of the *Book of Mormon*, stands in Temple Square in Salt Lake City. Smith's visions came to him as a young boy in Palmyra in 1821 and then again in 1823, resulting in the discovery of a lost book in the form of golden plates and the founding of the Church of Jesus Christ of Latter-day Saints. After Smith translated the golden plates, some 5,000 copies of the *Book of Mormon* were printed at the E. B. Grandin Press in 1830. This photograph was taken c. 1950.

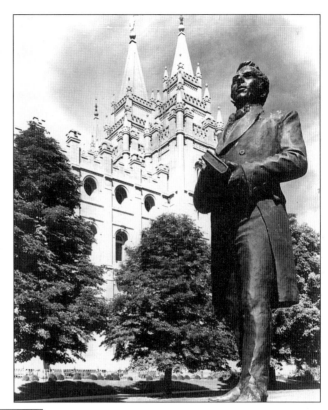

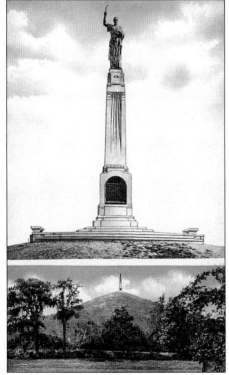

Joseph Smith is said to have found the golden plates on Hill Cumorah after receiving word and direction from the angel Moroni in a vision. A statue of the angel Moroni was erected atop the hill in 1935. Each part of the pier symbolizes a reference to the Church of Jesus Christ of Latter-day Saints. Pictured is Hill Cumorah c. 1940, before trees surrounded it.

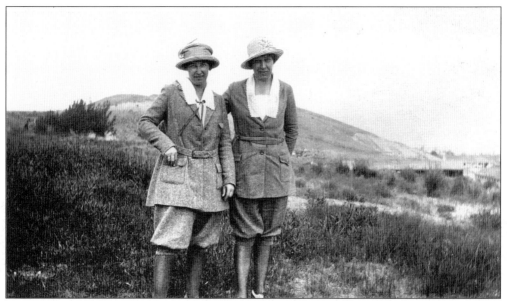

Near a treeless Hill Cumorah, two young women stand in their walking or riding clothes c. 1920. The picture was probably taken on the north side of Hill Cumorah, and the two women are likely sisters Lorene and Prudence Warner, who were raised and schooled in Palmyra and lived their entire lives seeking Palmyra's history.

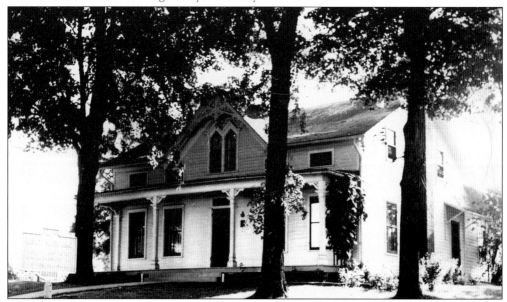

The Smith frame house sat on the east side of Stafford Road. After thorough review, historians of the Church of Jesus Christ of Latter-day Saints determined that the home was once a more primitive frame structure located on the west side of Stafford Road. Thus, in 1998, the place was stripped to the bare walls and the look of the original home was restored. Also, the road was moved, giving the impression that the house was relocated, but it is in the original spot. The meticulously restored home, with wooden fencing and a barn, believed to replicate the original Smith family farm is open for all. A log home and a visitors center welcome many from around the world. This picture was taken c. 1950.

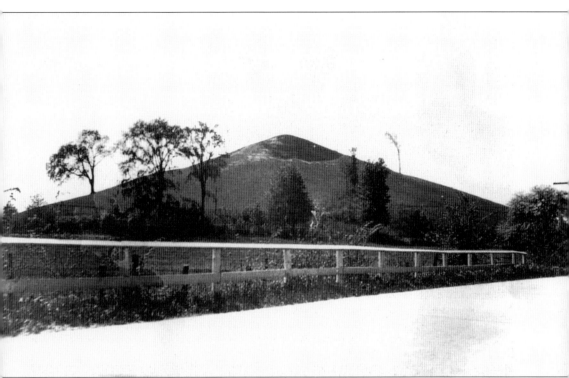

This 1930 view from Canandaigua Road shows Hill Cumorah as it stood many years ago. Each year in July, a large outdoor theater production re-creates the beginning of the Church of Jesus Christ of Latter-day Saints and the foundation of its beliefs. In June and July before the Hill Cumorah Pageant, large frames are put on the hill, speakers and lighting are placed in strategic locations, and more than 600 cast members come to rehearse their part in this depiction.

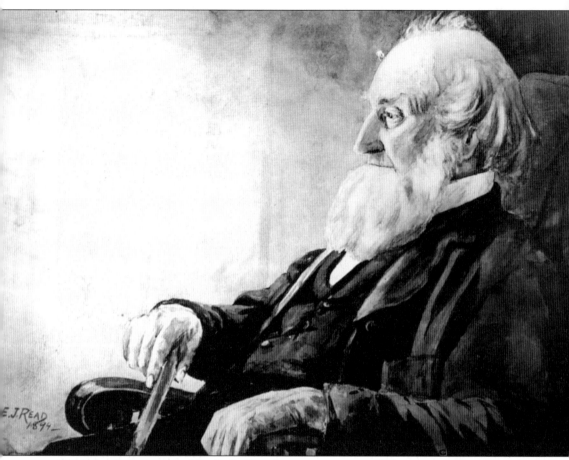

Maj. John Gilbert worked for E .B. Grandin as a typesetter. Gilbert was the typesetter for the first *Book of Mormon*. The book was printed at the Grandin Press offices on East Main Street. Gilbert is pictured at about 92 years of age in this photograph of an original painting by artist E. J. "Uncle Joe" Read, who typically painted watercolors and left for Panama to paint the digging of the Panama Canal and the surrounding Caribbean Islands.

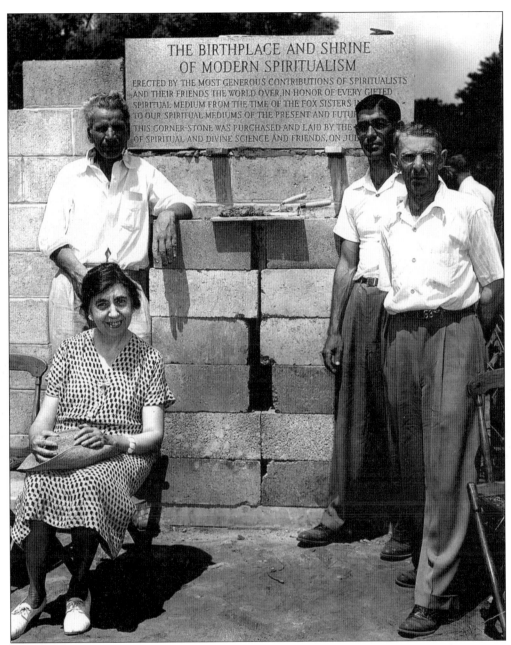

The Fox sisters' spiritualism started outside of Palmyra on Hydesville Road in the late 1840s. Rapping was heard and believed to be a communication with those passed on, which enticed even people of other religions seeking words from deceased family members and friends. In this c. 1950 picture, Sibyl Phelps is shown with the second monument to be placed at the original site of the Fox sisters' home. The first such monument was given by Palmyra resident Mrs. Cadwallader.

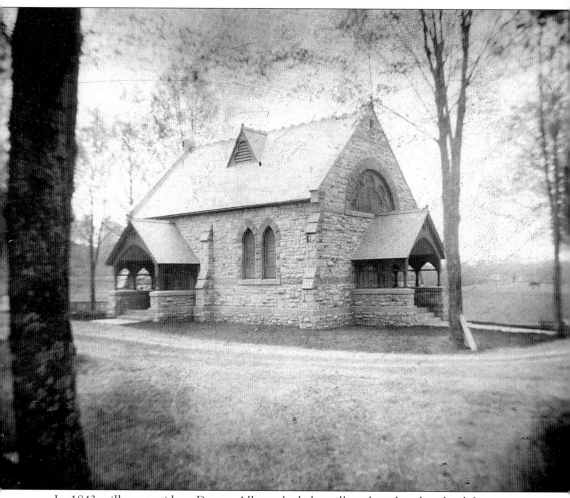

In 1843, village president Draper Allen asked the village board to buy land for a cemetery between Johnson and Vienna Streets for $500. In the Palmyra Cemetery, the Rogers Chapel was built in 1866. It was given by C. H. Rogers, son of Gen. Thomas Rogers and Harriet Holmes Rogers, with an endowment to maintain the building. Here, it is shown overlooking the main entrance to the cemetery, off Vienna Street in 1898.

Three
EDUCATION, ALWAYS IMPORTANT

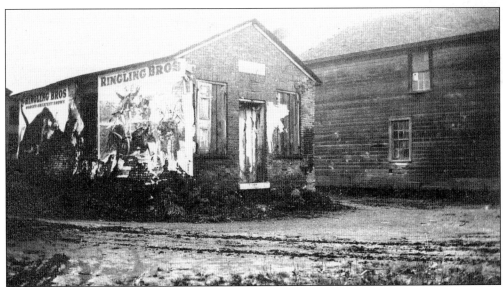

The first school in Palmyra was built in 1793 on the same hill as the first church. It was soon replaced with a cemetery for the early settlers. Later, several schools were begun in the village and town to accommodate the religious and political teachings of the settlers. Shown is one of the first three schools in Palmyra, which has outlived the laughter and the ring of the school bell and given way to boarded up windows, nailed doors, and billboards announcing the Ringling Brothers Circus.

The Democratic School was on the corner of Mill and East Main Streets. It was followed by the Federal School on Creek Road. A tax of $20 was levied to supply fuel and make repairs. Next came three districts with District 1 School on East Jackson near Fayette Streets; District 2 at West Main and Carroll Streets; and District 3 on the east side of Throop Street. The snow-covered Throop Street School stands empty and quiet c. 1930.

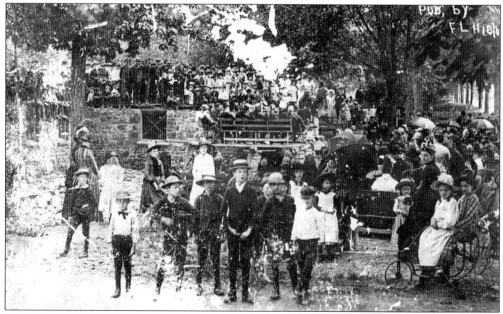

In 1889, a time capsule was put in the cornerstone of the new school building. The ceremony is pictured here. The time capsule was filled with information from the village of Palmyra, the bank holdings, the Declaration of Independence, the names of all local ministers, and many other small but pertinent pieces of information.

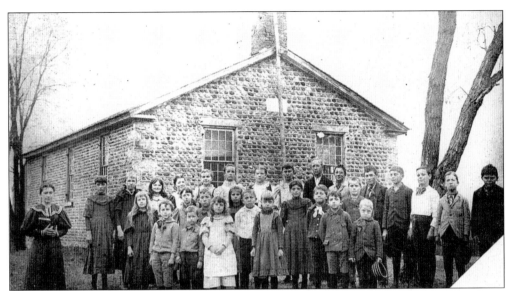

This cobblestone school was built at the corner of Route 21 South and Armington Road just south of Palmyra. Children of all sizes and ages pose with their teacher in the mid-1800s. This building still stands today and has been converted into a home.

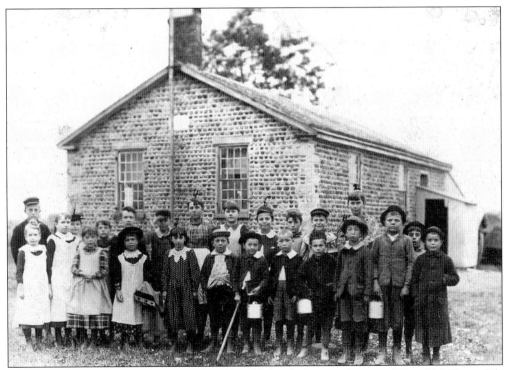

Shown are the students of the Armington Road School. Among them are "Girty" McKnutt (1), standing in the back near the tall boy on the left; Sadie Partridge (2), the tallest on the far right; Lulu Sampson (3), front row, in the dotted dress; Maude Morgan (4), back row, center; Edwin Lupold (5); and ? Mertz (6), front row, third from the right.

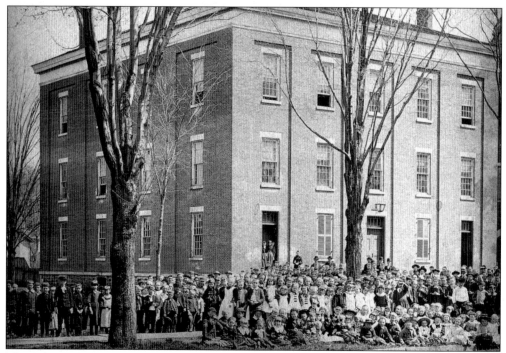

The Palmyra Union Classical School was built in 1848 on Canandaigua Street on the same lot as the current Palmyra Elementary School. On the board of trustees were A. P. Crandell, T. R. Strong, and Pliny Sexton. The building was three stories and cost $11,000. This school served for 41 years before it was torn down and replaced with a larger school. In 1857, the school district was incorporated into nine sections.

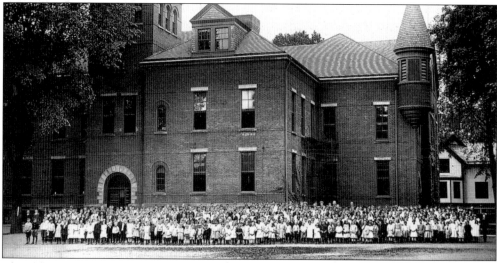

The Palmyra Union Classical High School, pictured in the 1890s, is the second school to stand on this Canandaigua Street lot. It was built in 1889, with a cornerstone holding a time capsule. Although a school for Palmyra students of all ages, it maintained the name of "high school." This school building had served for 34 years when the Palmyra Elementary School was built and dedicated in 1923.

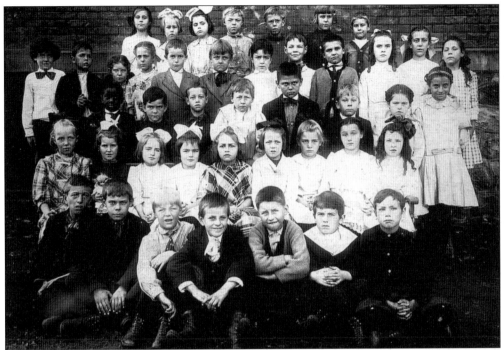

Shown is a second-grade class c. 1898. Identified on the left in the third row is Willy White, a good friend of O. J. Garlock, inventor and businessman.

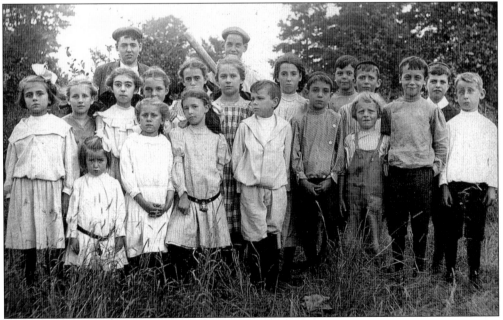

In this 1907 class picture, Sibyl Eugenia Phelps is in the second row, second from the left. The daughter of Julius and Mary Aldrich Phelps of the William Phelps General Store, she wanted to be an actress when she grew up. She played the piano, organ, and guitar and could write music. She went to the Eastman School of Music after graduating from Palmyra high school and traveled to attend acting school in New York City.

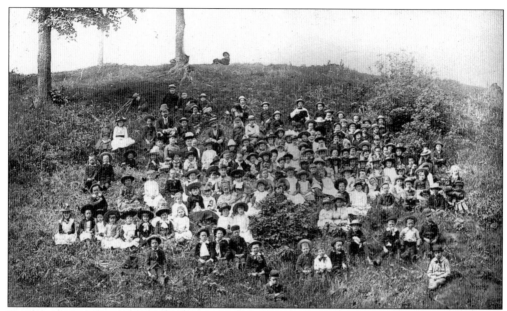

Pictures do not always speak a thousand words; some of them pose questions, as does this c. 1885 one. For example, why is the young man on top of the hill not with the others? Could he be in "time out"? What happened to the young fellow in the upper left with crutches? Why are only six of the children not wearing hats? (Photograph by George Elton.)

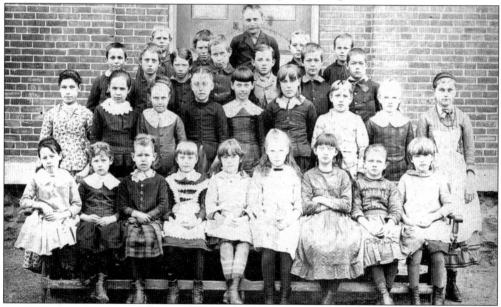

This 1887 photograph is titled "My School Mates in Miss Howe's Room." From left to right are the following: (first row) Nora Moor, Nellie VanDuzer, Mabel Reed, Lucy Craig, Lillie Cunningham, Agnes Gallagher, Belle Smith, Mabel Trimper, and Nellie Lawler; (second row) ? McDonald, Nancy Rush, Julia Miller, Mary Collins, Nettie Dunn, Dottie Barker, Sadie Tuttle (X), Jennie Poyzer, and ? Wardwell; (third row) George Goodrich, Willie Weber, unidentified, Louis Veeder, Anthony Hornsby, Harry Seeley, and Irving Young; (fourth row) Walter Brown, Harry Jones, John Weber, Fred Moore, and Pliny Smith.

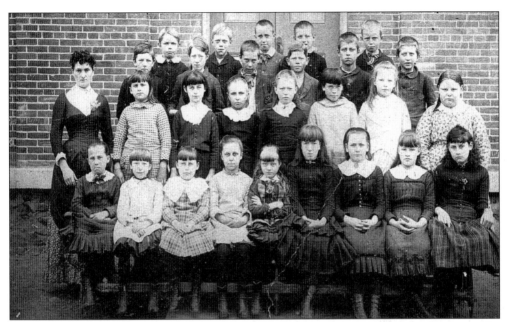

Standing in front of the school building in 1887 is Ida Dixon's class. From left to right are the following: (first row) Ellen Jones (Dorman), Anna Burns (O'Brien), Nellie Flannigan, Minnie Crandall, Hattie Huxley, ? Pulver, Grace Pendry (Crandall), Clara Nelson, and Bridget Stanley (Parker); (second row) teacher Ida Dixon, Maude Williamson, Lottie Lakey (Morgan), Bessie Barker, Maude Pulver, unidentified, Mamie Lawler, and Lida Hibbard; (third row) Herbert Fox, ? Coomber, Charles Daily, Eddie Riley, ? Stone, and ? Hart; (fourth row) Frank Ward, Fred Coer, Maynard Reed, Harry Williamson, and unidentified.

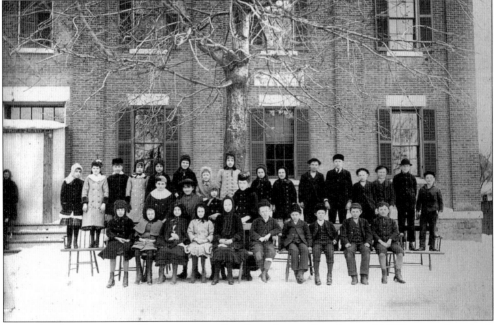

Dressed in heavy coats and hats, a group of students braves the winter of 1887, as teachers look on from the doorway of the old Union Classical High School.

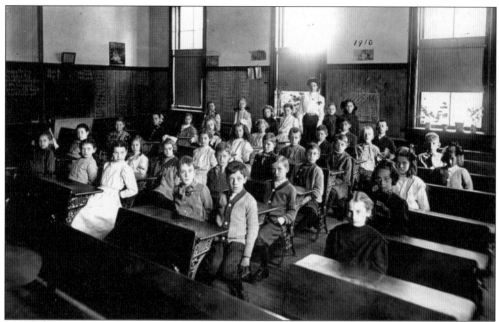

Pictured in 1910 is Jennie Barron's third grade. Included are the following: Mildred Amidon, Helen Smith, Marjorie Mason, Gladys Vasseur, Theodore Weber, Leo Jones, Herbert Gates, Leland Smith, Bob Matthews, Milo Chapman, Charles Fitzgerald, George Albert Tuttle, Ivan Foster, Glenn Cook, Anthony Cotrones, Kenneth Tiffany, Delia Post, Lynn Gavin, Flossie Dibble, Katherine Parsons, Irene Robbins, Mildred Gassner, Gladys Russell, Susan Flynn, Mamie Schadder, Cora Bullard, Cynthia Van Holder, Elizabeth Crockston, Anna Mewman, Arna Duffy, Anna Duffy, Beryl Dran, Pauline Burbe, and Mary Hughes.

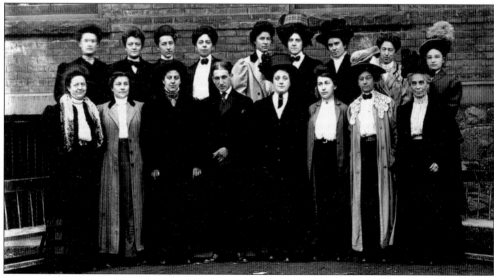

The Palmyra high school faculty poses for a portrait c. 1910. From left to right are the following: (first row) Mary McGrath, Anna Nelson, Isabel Adams, Prof. W. Bullock, Mabel Durfee, Genevieve K. Walter, Alice M. Doherty, and Jane Harse; (second row) Minnie Crofoot, Margaret Stevens, Reeva Sutton, Hazel P. Jenne, Lore Chase, Hannah Smith, Lucy Wardlaw, Mildred Smith, and Lena Weeks.

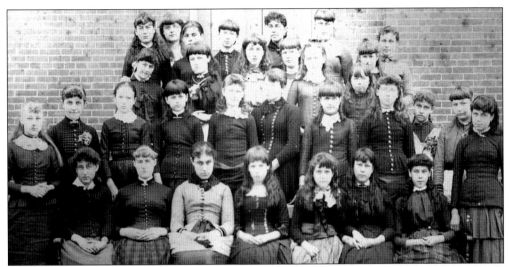

Pictured in the Junior Girls Room in 1888 are, from left to right, the following: (first row) Nellie Troop, Mary Smoulton, Georgia Snook, Nellie Davis, Belle Prichard, Carrie Walter, and Julia Goodrich; (second row) Carrie Lewis, Kattie Clark, Nellie Gorman, Sara Williamson, Mamie McGrath, Josie Beal, Daisy Jeffery, Clara Stoddard, Fanny Yeomans, Nellie Morse, and Nellie Moore; (third row) Alice McGrath, Madge Bruner, Nellie Stone, Lizzie Heath, Della Brightman, Ora Moore, and Kitty Feller; (fourth row) Kitty Kelly, Kate Jenner, Ethel Thayer, Winnie Landon, Ida Clark, Edna Perry, and teacher M. L. Wismer.

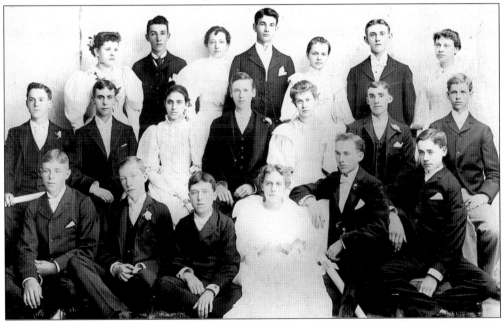

This is the graduating class of 1894. From left to right are the following: (first row) Edward Fisher, Louis Conant, William Corning, Sadie Tuttle (Ziegler), Anthony Hornsby, and William Cavanaugh; (second row) Pliny Smith, Daniel Spier, Clara Sawyer (Sibbitt), Pliny Riggs, Mabel Kent, Major Gage, and Frederick Cleveland; (third row) Harriet Fish, Harry Nelson, Olin Corning (Sanford), Loren Cook, Sarah Harrison (VanAlstine Lenis), Charles Clark, and Lillian Pannell (Briggs).

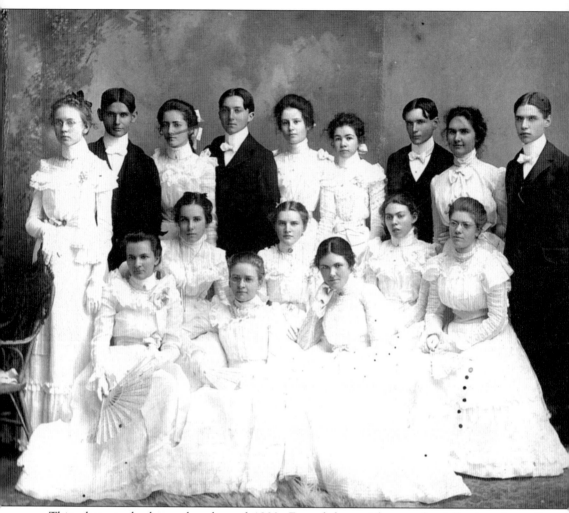

This photograph shows the class of 1900. From left to right are the following: (seated) Katherine Lent, Mabel Tuttle, Elizabeth Mertz, Blanche Amidon, Margaret Flynn, Grace Millen, and Winifred Paskett; (standing) Edna Huxley, Edgar Congdon, Anna Hartman, Burton Borheim, Lillian Rumrill, Bertha Garrison, James Curran, Rose Forderkanz, and Charles Jackman. (Photograph by George Elton.)

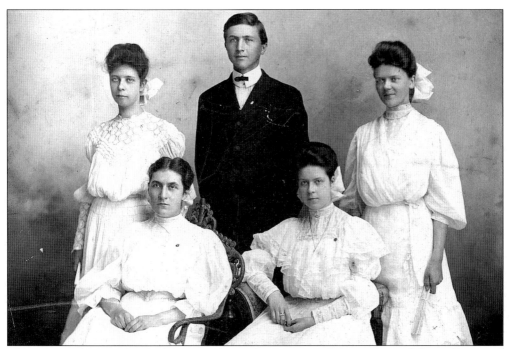

The 1905 graduating class had five members. They are, from left to right, as follows: (first row) Harriet Sherman, and Bessie Cray; (second row) Neda Cunningham, James Reeves, and Olive Jeffery. (Photograph by George Elton.)

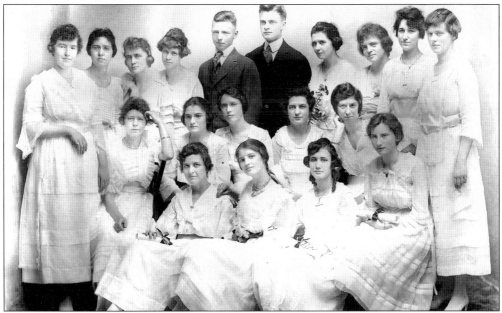

The Palmyra high school class of 1919 poses for a picture. From left to right are the following: (first row) Elsie Barrett, Alice Trautman, Flossie Dibble, and Mildren Amidon; (second row) Louise Young, Anna Newman, Anna Brown, Katherine Parsons, and Dorothy Bush; (third row) Susan Flynn, Elizabeth Crookston, Anna VanGee, Hazel Randall, Cuyler Reeves, George A. Tuttle, Arvena Duffy, Marjorie Hanagan, Frances West, and Lena Brown.

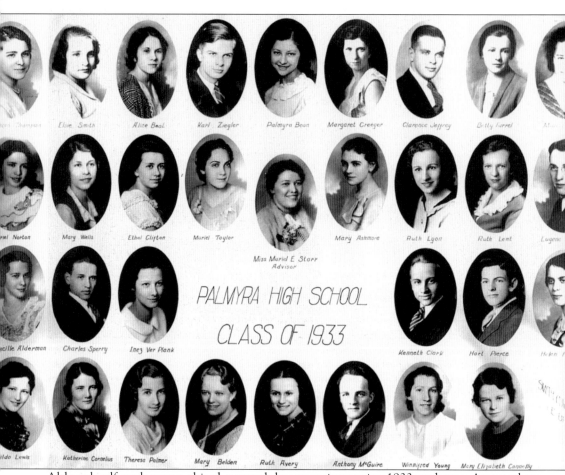

Although self-explanatory, this photograph has many interesting 1933 graduates. Among them are Palmyra Bean, Theresa (Palmer) Otte, Ziegler, Knapp, and many others.

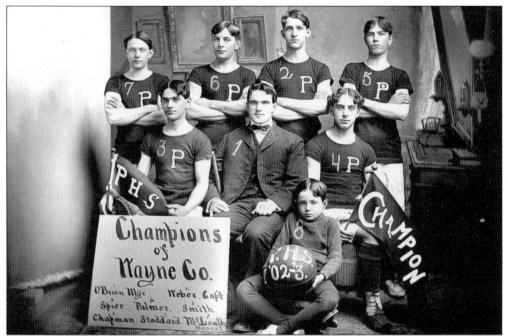

Shown is the Palmyra high school basketball team of 1902–1903, winner of the Wayne County basketball championship. From left to right are the following: (first row) mascot McLouth; (second row) Spier, manager O'Brien, and Palmer; (third row) Stoddard, Chapman, captain Weber, and Smith. (Photograph by George Elton.)

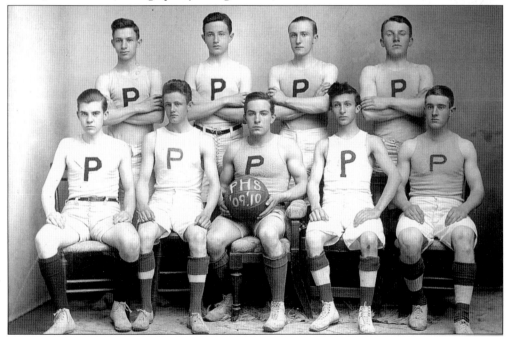

Sports have always been a major part of the Palmyra high school. Shown here is the men's basketball team from 1909–1910. The girls' basketball program began c. 1925. (Photograph by George Elton.)

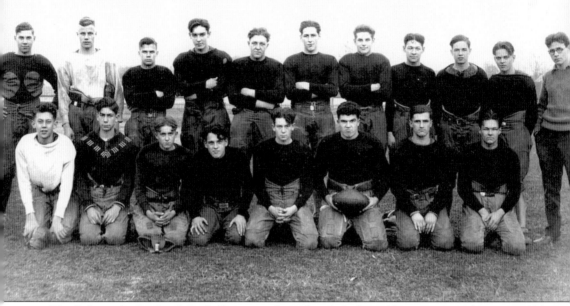

The Palmyra high school football team is dressed with little padding sometime between 1920 and 1930. From left to right are the following: (first row) I. Hornsby, W. Morgan, R. Powers, R. Cullen, K. Hughes, D. Wehrlin, G. Wehrlin, and W. German; (second row) J. Bernhard, R. McClain, J. Nesbitt, E. Hall, M. Chittenden, N. Barnhart, S. Forshay, D. Palmer, E. Hickey, C. Jeffery, and coach F. T. Deci.

Four
FROM THE ERIE CANAL TO TRAINS

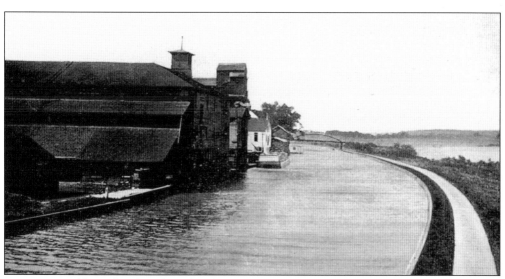

In 1840, Franklin Lakey bought a slaughterhouse on the north side of the Erie Canal. On the south side, he built a large warehouse, malt house, and coal yard. A major buyer of produce, he hired many men who worked day and night to keep the barges on schedule. Thomas Cook, author of *Palmyra and Vicinity*, remembers Palmyra during this canal boom "with streets lined with wagons waiting one after the other to unload their produce for shipping." Those that could not wait to unload left barrels and bushels stacked on the street for placement on a barge. This photograph dates from c. 1875.

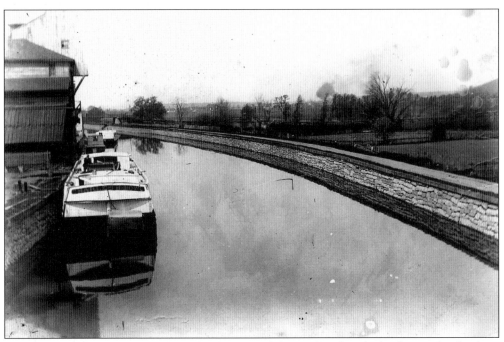

Here is a c. 1880 view of the Lakey Warehouse, with barges lined up for loading and unloading.

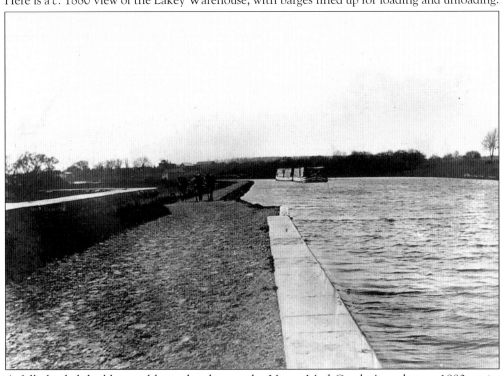

A fully loaded double canal barge heads over the Upper Mud Creek Aqueduct c. 1880 on its way to the village of Palmyra to off-load goods for local merchants and to reload goods and produce for shipment. Mules are pulling this barge over the aqueduct, which is a trough filled with water taking the canal over Mud Creek.

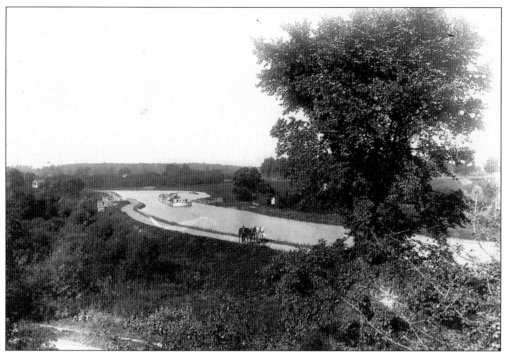

This 1880s view, looking from the hill (Burnham Heights) just south of the canal aqueduct, shows the towpath mules and the barge.

Known as the Palmyra Aqueduct because it is so close to the village of Palmyra, this aqueduct's original name is the Upper Mud Creek Aqueduct and is located in the town of Macedon. It was built in 1858 by a man named Jacob Richmond. The wooden tub has since rotted, leaving the empty piers.

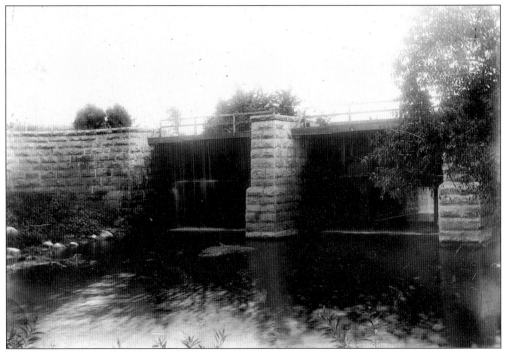

Here is a lower view of the aqueduct, showing a closeup of the tub c. 1900.

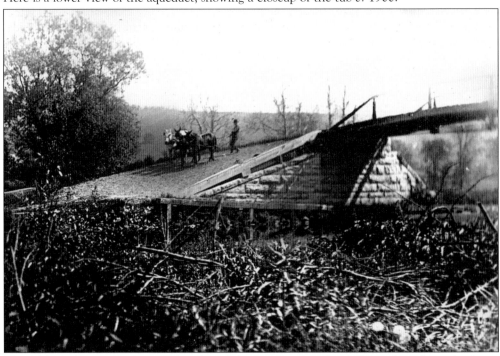

The Aldrich Change Bridge, a Whipple-style bridge, is pictured c. 1880, with mules and a driver crossing the towpath from one side to the other. This bridge, the only one of its kind left today, was restored to its original design and construction with a federal grant. The town of Macedon is the owner and keeper of the bridge, which stands in Wayne County's Aqueduct Park.

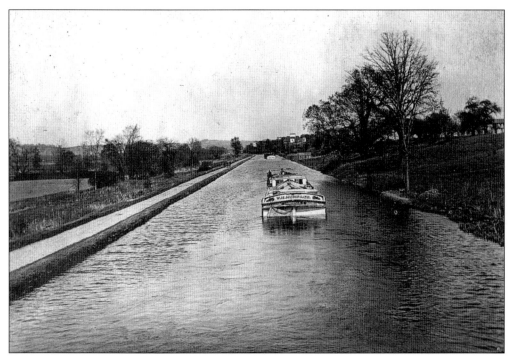

A barge named the *W. H. Humpace* appears to be traveling west toward Macedon c. 1900. This barge is following another of similar style and probably similar load. Along this stretch of the canal, it is difficult to tell which direction the barges are heading, as the banks are countryside and the landmarks are too distant.

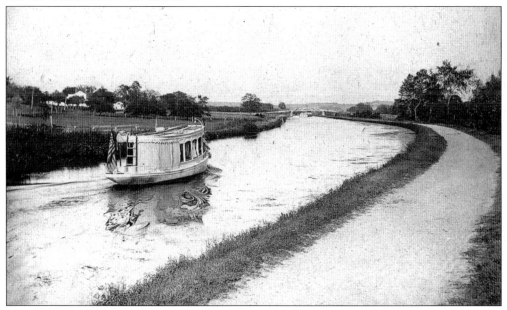

This 1900 picture of a unique packet boat shows a different time and a more relaxing trip on the old Erie Canal. An American flag is on the stern, and there appear to be no mules in tow. Visible in one of the window-like openings on the right side of the craft is a woman dressed in fine clothes.

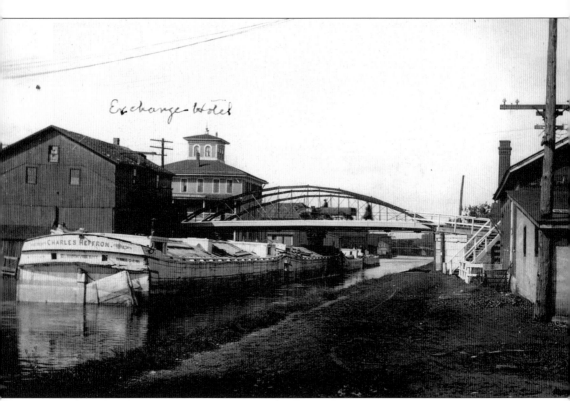

The barge *Charles Hefron*, last in a line of four barges, approaches the Railroad Avenue Bridge, heading west. This pre-1910 photograph shows the old enlarged Erie Canal with East Main Street ending at the bridge. A Galloway warehouse and the Exchange Hotel are on the south side of the Railroad Avenue Bridge, both to the left. In the 1830s, Butler Newton built the Exchange Hotel, which is gone now, replaced by a restaurant.

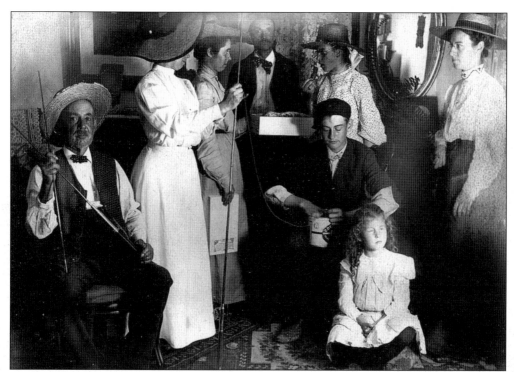

This family has decided to go fishing, perhaps on a Saturday or Sunday afternoon. Preparation is a good part of fishing, and everyone gets a pole. Dress was not casual like it is today; this is about as casual as the ladies and gentlemen dressed in 1900.

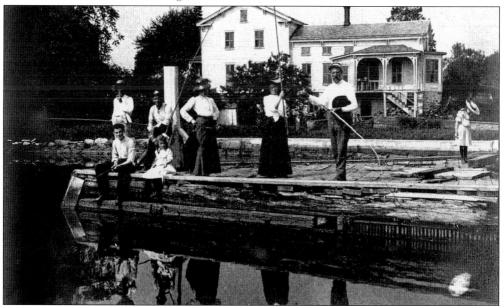

The old fishing hole was located at Lock 60 in Macedon, where the sides were wide and the stones large. It was a double-lock system, and there were plenty of places to stand. This 1900 photograph shows the old locks. Notice the old white house in the background; that house is still visible from this location today.

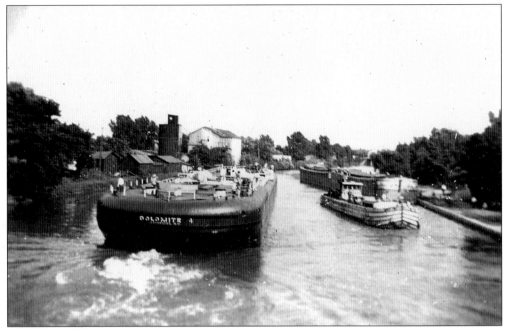

An old Dolomite barge heads out of a lock, while the other boats on the side wait to get through the lock c. 1920. The process took a great deal of time, especially with the new Barge Canal when only one lock was used for both east and west traffic.

Here is an 1890s view of the winding Erie Canal from Prospect Hill in Palmyra. Shown is a typical canal community with buildings lining the canal on one side and a countryside dotted with fields of corn and wheat on the other side.

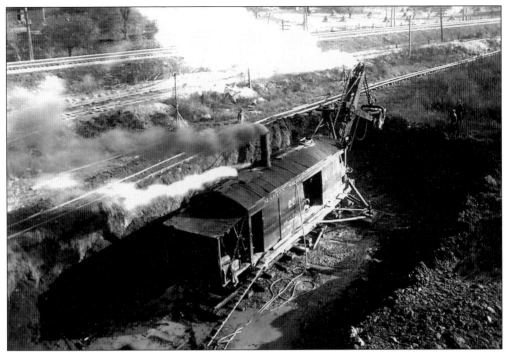

The digging of the new Barge Canal in 1910 moved most of the Palmyra section of the canal about 300 feet to the north, sometimes more and sometimes less. The equipment used was machinery like this steam shovel, pictured in its earliest form. Surely the steam shovel was better than digging by hand, as the first Erie Canal was dug.

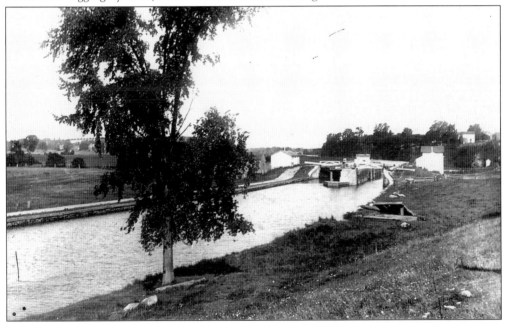

Shown is the old Lock 60, west of Palmyra in Macedon. Today, Lock 60 is a park through which visitors can walk to get the feeling of how narrow the enlarged old Erie Canal was. This portion of the Barge Canal was built south of the old Erie Canal.

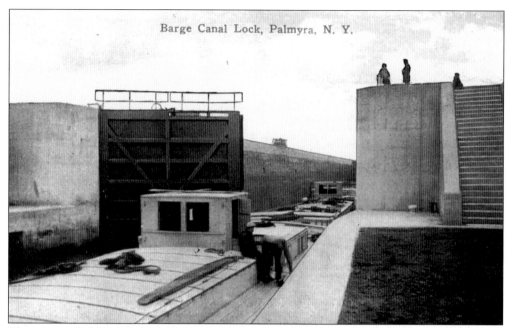

The new Lock 29 on the new Barge Canal was completed in 1910. Unlike Lock 60, Lock 29 was a single lock. In this view, canal traffic is still busy, with barges lined up to go through the lock. Although the picture identifies the location as Palmyra, the lock is actually on the outskirts in the town of Macedon.

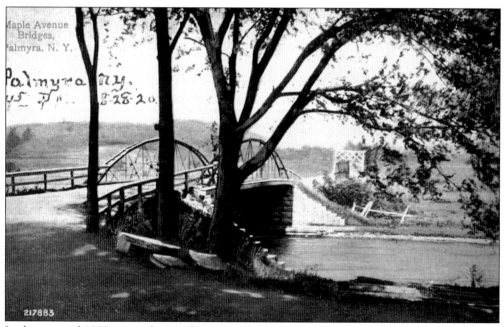

In this unusual 1920 scene, the Maple Avenue Bridge on the old Erie Canal is in the foreground and the new Barge Canal bridge is in the background. The road at the bottom is likely Canal Street.

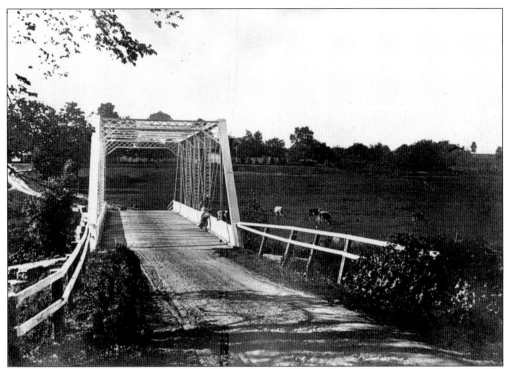

The writing on the back of this photograph notes, "this is the bridge over our creek just north of Yellow Mills." Presumably, this 1910 view is looking south and the bridge is the one over Ganargua Creek just off Route 31. A newer bridge is in this location today.

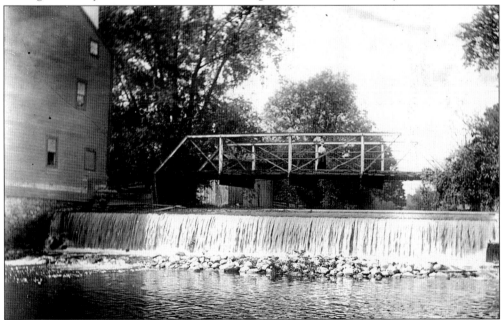

A woman stands watching the falls of Ganargua Creek c. 1890. The bridge is just north of Yellow Mills on Yellow Mills Road. The picture includes the dam put in for the mill. To the left of the picture is the mill, which has been gone for many years.

Looking west, this is a wider view of the Yellow Mills and the bridge. The 1890s picture was probably taken in the summer, as the stream is very dry and no falls are running. A note at the top of the picture states that E. J. "Uncle Joe" Read painted this mill several times.

Pictured in the mid-1860s is the Harrison Mill, located near East Palmyra on the Ganargua (Mud) Creek. In the early days before the canal was complete, damming of this creek required permission from the state, since it was a navigable waterway. The Galloways and Durfees had mills that were a major part of the industry on Mud Creek. Wherever there were farmers growing grain, mills were needed.

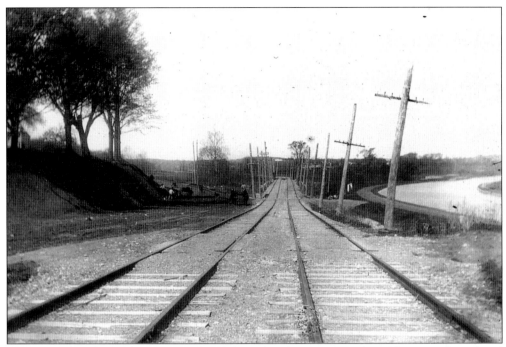

This 1910 view shows the Erie Canal and the railroad existing together. However, the railroad was able to carry more freight and to take passengers farther west. Also, it operated in the winter months. Thus, the railroad soon took away much of the canal's freight and many of its passengers.

The New York Central Railroad Company was one of two railroads that ran through Palmyra. The other was the West Shore Railroad. This 1866 shipping ticket, marked for J. T. Beddlecom, in Macedon, is for one stove from the Lyons Station to the warehouse in Macedon. Noted on the back of the ticket are shipment rules and regulations.

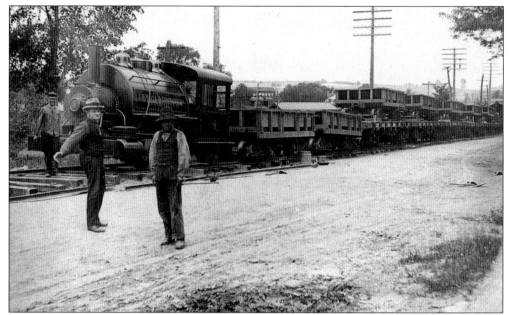

Three railroad men are working this stretch on Railroad Avenue in Palmyra c. 1915. They appear to be repairing a broken track; note the shovels lining the side of the track. Keeping the cars and tracks in order was a major job. A sign on the engine says "J. G. White & Company, New York City, NY."

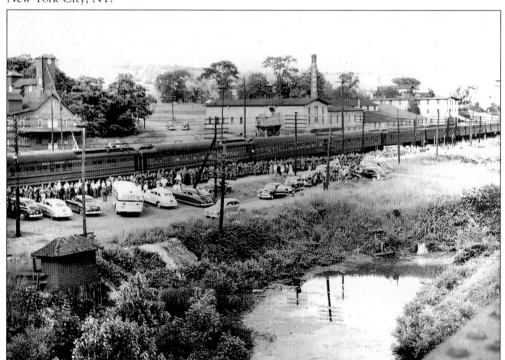

This busy train station was located just northeast of the village near Walker and North Creek Roads. Lined up waiting for the train in this 1941 photograph are hundreds of people, most likely loved ones bidding farewell to soldiers and sailors leaving to fight in World War II.

Five
THE PEOPLE AND THEIR INFLUENCE

Pictured c. 1900 are boyhood friends Fred Clemons (standing) and Will Sampson. When a spot opened for a student at Annapolis, Clemons recommended Sampson. Clemons was a Civil War lieutenant colonel and a Palmyra postmaster. Sampson was a rear admiral who traveled the world and became a war hero.

Thomas Cook, author of *Palmyra and Vicinity*, stands with his nurse in 1930. In his nineties, this incredible man wrote a book describing life in Palmyra from memory, noting every business, street, house, hill, church, and family connected with the property. Although some say it contains inconsistencies, the book offers information that no other book does. The book *Palmyra a Bicentennial Celebration*, edited by Betty Trokosky, was published as an extension of Cook's book.

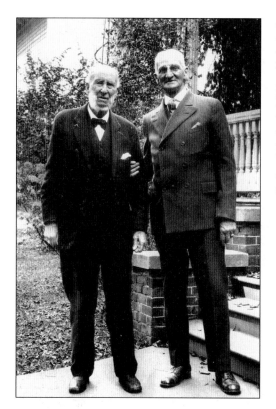

Dr. Harriet Adams was born in 1826. Well before women's rights were gained, but certainly not before the fight had begun, she studied and became a physician. Pictured here in the 1870s, she was one of the first woman medical doctors in America. She died in 1886 after a long and good practice.

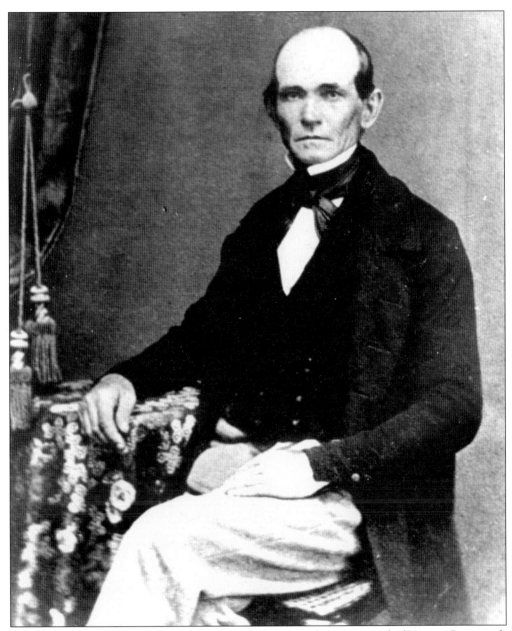

Professional weaver James Van Ness started a business on the eastern end of Vienna Street with an eight-foot-wide weaving loom and a Jacquard attachment. The loom was wide enough to make coverlets in one complete piece, an improvement over those that had to be sewn together. Van Ness's original designs were the horn of plenty, flowers in an urn, and the signature design of the spread winged eagle noting "E. Pluribus Unum" with Lady Liberty. In 1854, Van Ness sold his business to Ira Hadsell and moved to Michigan. Dedicated to the art of coverlet weaving, the Alling Coverlet Museum in Palmyra contains the work of Van Ness and Hadsell, as well as that of many other 19th-century weavers. This picture dates from c. 1855.

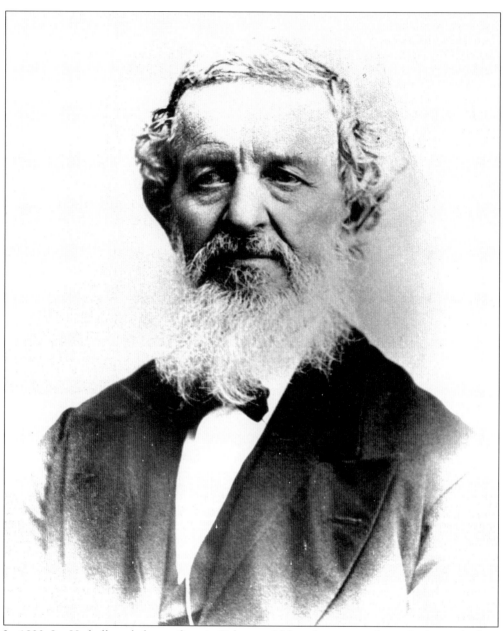

In 1820, Ira Hadsell settled on a farm in Palmyra. Although a weaver by trade, he worked on the Erie Canal until its completion. He applied for work across the street from his farm at the shop of expert weaver James Van Ness. He worked for Van Ness until 1854, when he bought out the business with all the equipment and designs. He continued to make coverlets until the mid-1880s, as small weavers gave way to the large factories. He then closed the shop and returned to his 30-acre farming business, raising milk cows and selling and delivering milk to the community. This picture dates from c. 1865.

Walter Paige Smith partnered with Charles Ziegler in the Smith and Ziegler Jewelry Store. The store operated for many years at the corner of Cuyler and East Main Streets. This portrait was taken c. 1884. (Photograph by a Mount Morris photographer.)

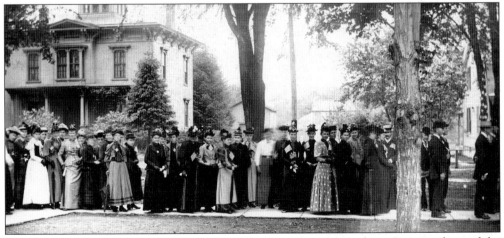

The Palmyra Memorial Day Parade of 1894 is beginning on East Jackson Street in front of the home of the Honorable Nelson Sawyer. Patriotic residents are lined up and ready to head to the Palmyra Cemetery to honor the fallen soldiers and sailors. Participants include Mr. Converse, carrying the flag, Prof. G. W. Pye, and preceptress Elizabeth Peabody.

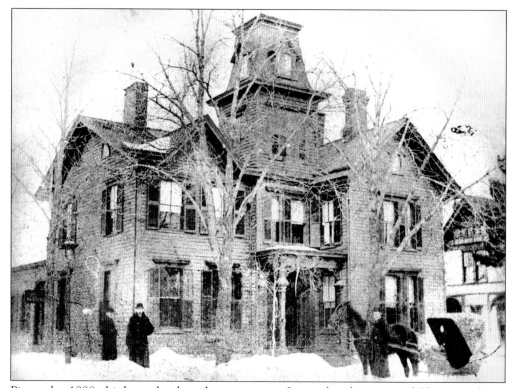

Pictured c. 1888, this house has been home to many. Located at the corner of Clinton and East Main Streets, it was built by Peleg Holmes, who gave it to his daughter and son-in-law Gen. Thomas Rogers. Later, it became home to Dr. Herman L. Chase, who is standing on the left on the Clinton Street side with a friend. A sleigh, perhaps belonging to someone who is in need of the doctor's services, is waiting out front. Businessman and owner of the Garlock Packing Company, O. J. Garlock owned the home in the 1890s.

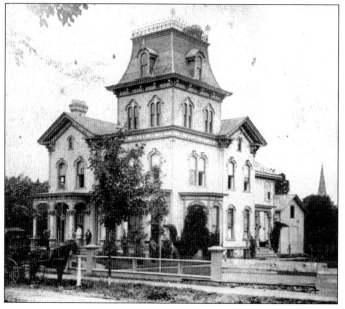

Shown in the 1870s, this stately looking home belonged to local merchant B. H. Davis. The home was later owned by Judge Nelson Sawyer. Today, it is the Murphy Funeral Home. Mill Brook runs just to the east of the house.

Built in 1850, this home was the residence of influential Palmyran Carlton H. Rogers, son of Gen. Thomas Rogers and Harriet Holmes Rogers. C. H. Rogers was a businessman and property owner. He gave funds to build the Rogers Chapel in the Palmyra Cemetery. Today, Rogers's home is the Palmyra King's Daughters' Free Library. This photograph dates from c. 1870.

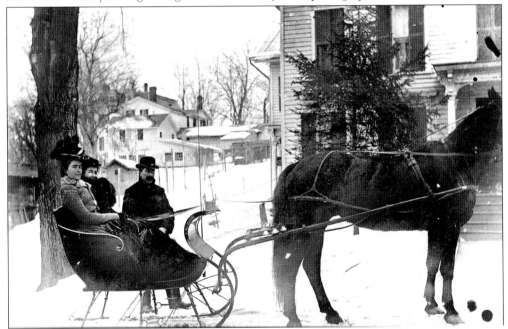

By 1898, the old Thomas Rogers house had become the home of Olin. J. Garlock (standing). In the sleigh, closest to the house, is Lillian Garlock. The Garlock House, as it is called, is still painted white and has been home to fine restaurants since the mid-1940s.

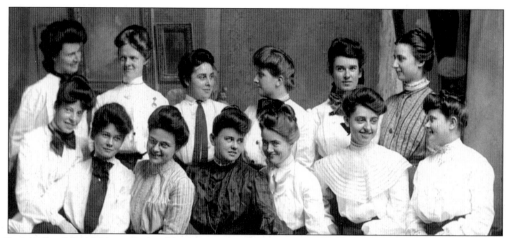

It is May 30, 1904, and the library women are posing together. From left to right are the following: (first row) Ziepha Boyton, Mattie Ryan, Georgia Bilby, Emma Gould, Lou Elton, Ethel Leach, and Nellie Congdon; (second row) Lou Chase, Emily Cornell, Mabel Tuttle, Mabel Durfee, Lou Wardlaw, and Bess Phillip. (Photograph by George Elton.)

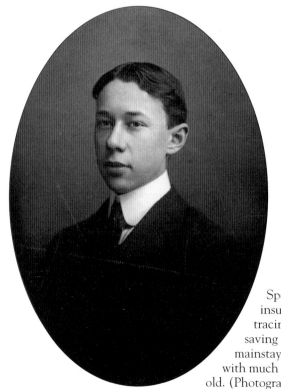

Spencer Knapp, pictured in 1885, ran an insurance agency, but his interests were in tracing Winston Churchill's family roots and in saving Palmyra's downtown from decay. He was a mainstay of Historic Palmyra, which credits him with much of its success. He lived to be over 100 years old. (Photograph by George Elton.)

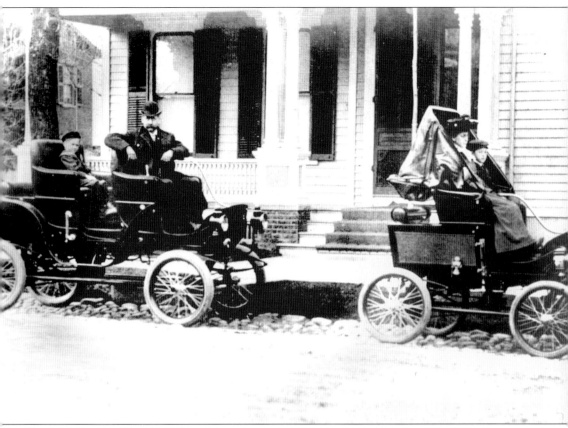

Olin J. Garlock and his 1901 Toledo steamers are parked in front of his home in 1901. Seated in the second car are O. J. Garlock and his son Harold. Garlock and B. H. Davis had the first cars in Palmyra.

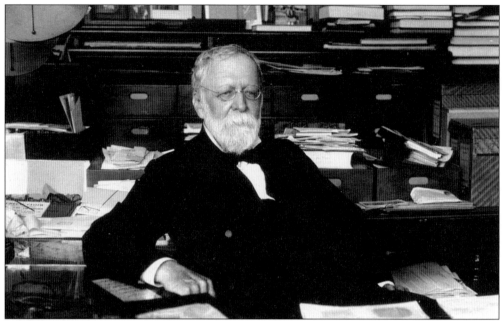

Pliny T. Sexton, pictured in 1910, was president of the First National Bank in Palmyra and a very charitable man. He left Palmyra's citizens the Main Street Park, Park and Club Rooms, Prospect Hill Park, and the C. H. Rogers house for the Kings' Daughters' Free Library. Pliny T. Sexton donated money for the first reading room in 1899. He was president of the local board of education in 1889 and was chancellor of the New York State universities.

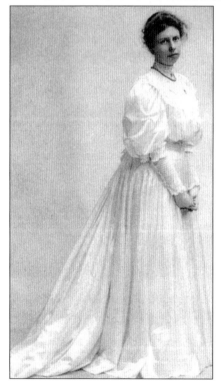

Mabel Hopkins Hornsby was married on August 22, 1906. This picture was taken on her wedding day. Little more is known about her.

Shown c. 1903 are Julius Phelps, owner and operator of the William Phelps General Store, his wife, Mary Aldrich "Mayme" Phelps (right), and daughter Sibyl Phelps. Phelps was the son of William and Catherine Phelps, who bought the Phelps Store in 1868. Although the store closed in 1940, members of the Phelps family lived there for 108 years. Today, the Phelps store museum serves as a fine example of an original general store and an early business and family home.

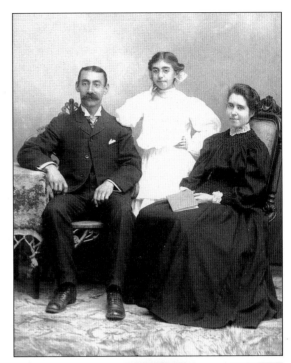

Sarah Tuttle Ziegler was the treasurer of the King's Daughters' Free Library and in charge of its historical department. She is shown in 1939 sitting in the library when it was in the Griffith Block located next to the Palmyra Village Hall. It is said that if one needed any information on Palmyra, Sarah Ziegler was the person to see.

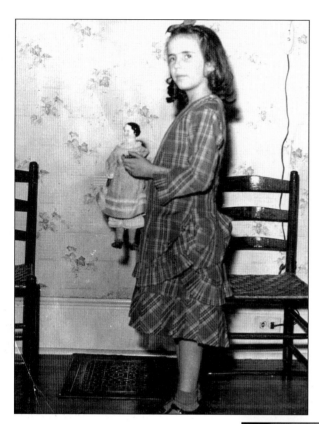

Lorene Warner holds one of her favorite dolls c. 1910. She worked in the office of McPike's Appliance Store on East Main Street until it burned. Needing an interest, she studied and shared the history of Palmyra and became the official historian. She wrote for the *Palmyra Courier Journal* and collected items for Historic Palmyra. Many of the collections in Historic Palmyra's museums today are credited to her efforts.

Prudence Warner was the librarian for the King's Daughters' Free Library for many years. She shared her sister Lorene's love of Palmyra history. She is pictured c. 1902 at age four with one of her favorite dolls. The Warner girls' doll collection is in the Palmyra Historical Museum.

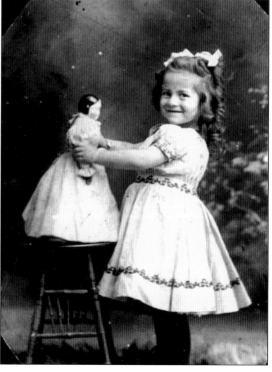

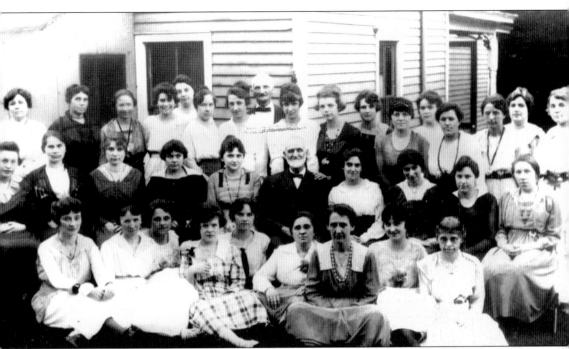

"Uncle John" Garlock is pictured in this group on August 12, 1919, celebrating his birthday. Always called Uncle John, he worked for the Garlock Packing Company, owned by his son, Olin J. Garlock. From left to right, the participants are as follows: (first row) Reta Trumbell, Nellie Hart, Clara Gunkler, Mabel Burton, Theresa Adams, Margaret O'Brien, Mae Garlock, Alma Wenke, and Loretta Taylor; (second row) Delia Post, Mary Marks, Allie Gowers, Nellie Fiero, Agnes Malloney, Uncle John, Hermina Whiting, Alice Shaw, Emily Fisher, and Lucina Goldsmith; (third row) Mrs. Philly, Mrs. Hennessey, Edna Philly, Maude Cunningham, Miss McMullen, Marie Philly, Emma Kemp, Ed Tappenden, Mertie Smith, Miss DeWitt, Vera Smith, Mary McGuire, Alma LaFevre, Mrs. Fred Walton, Julia White, Elta Cady, and Mrs. Sydmore.

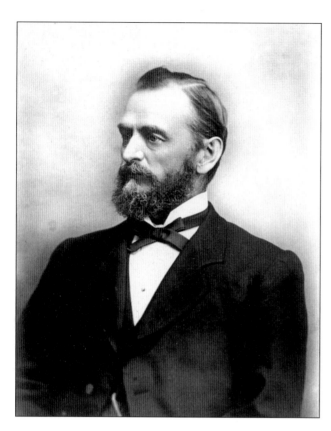

Pictured in 1902, Judge Charles McLouth lived for 40 years in the house he had built on the northeast corner of Cuyler and East Jackson Streets. He was a building committee member of the new Zion Episcopal Church, a director of the First National Bank, and the father of Agnes McLouth Griffith, Sen. Henry Griffith's wife, who became president and treasurer of the *Palmyra Courier Journal* upon the death of her husband and was a great benefactor of Historic Palmyra.

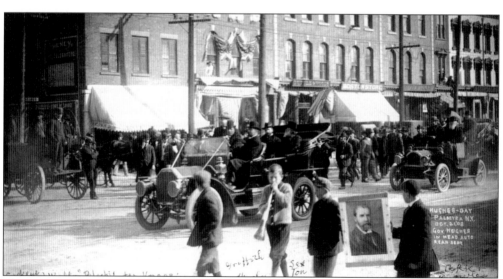

This 1908 parade is honoring New York State's governor Charles Evans Hughes, whose car is in the center. Hughes is sitting in the back left with Pliny T. Sexton on his right and Sen. Henry Griffith in the front. Griffith, the son of Sen. Frederick W. Griffith, resigned as director and treasurer of Garlock Packing in 1929 and with his brother, Frederick A. Griffith, purchased the *Palmyra Courier Journal*.

Edward "Tap" Tappenden had been an employee of the Garlock Packing Company for 30-plus years when he retired. After his retirement, his mission in life became serving and helping those in need. He was a true neighbor to all Palmyra. This picture dates from c. 1880.

In the year 1901, George G. Throop simultaneously served as both the police chief and the fire chief. In Palmyra history, this is the only time that such extreme responsibility was placed on one man. Throop also owned the Eagle Hotel for a time. In 1865, as a young man, he was one of the 500 people who bid good-bye to Pres. Abraham Lincoln when his funeral train stopped in Palmyra for water.

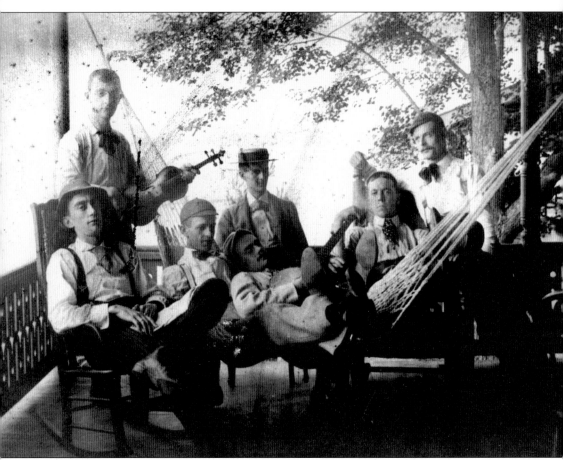

This 1888 photograph is titled "seven Palmyra boys or S.P.B." The seven are sitting on a porch, playing the fiddle and banjo. Clean-cut and shined up, they later became some of Palmyra's most respected citizens. From left to right are Charles North, Clifton Bradley, Jarvis Merrick, Frank Drake, Fred Sanford, Louis Ziegler, and Coles Seeley.

Six
EARLY INDUSTRY AND BUSINESS

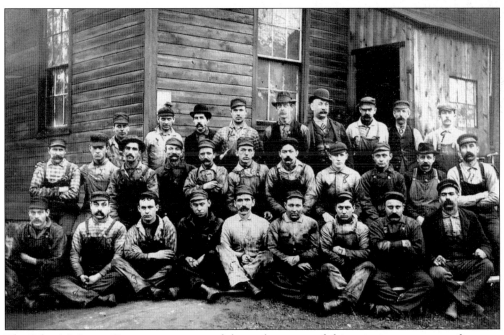

The John M. Jones Company was one of the early names of this printing press manufacturer. John Jones settled in Palmyra in the 1850s. Pictured in 1875, from left to right, are the following: (first row) two unidentified people, Bill Trumbell, unidentified, Henry Wood, unidentified, Irving Young, unidentified, and Mr. Cray; (second row) four unidentified people, Billy Sebedra, three unidentified people, John Jeffery, Billy Whittaker, and unidentified; (third row) four unidentified people, Dick Derrick, Fannie Jones, George Truax, Ed Foster, and another Mr. Cray.

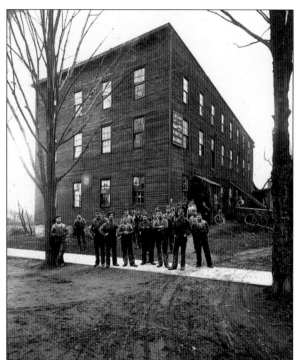

"J. M. Jones & Co. Manufacturers of Printing Machinery," as the sign reads c. 1875, had a number of addresses before settling on West Jackson Street near the Wayne County Fairgrounds. J. M. Jones came up with a number of inventions, but after little success, he focused on the manufacture of printing machinery. At least 15 printing press brands were made by his company and its descendants.

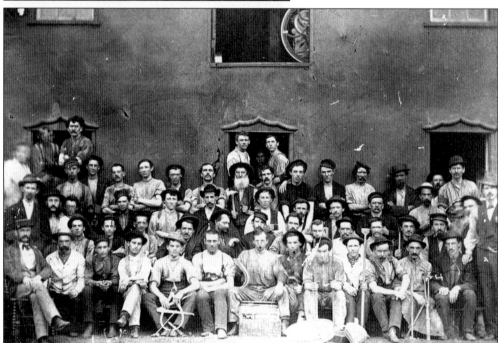

The Old Globe Works Printing Company was another name for the J. M. Jones printing press manufacturer. In operation from 1860 to 1923, the company began on the south side of West Jackson Street and then extended to the north side directly across the road. The company made Peerless, Global, Star, Ben Franklin, and other printing presses and cutters. This picture dates from c. 1880.

Pictured in 1885, John Shimmin's Blacksmith Shop on Fayette Street was in business until 1922. Shimmin's bought the old Bingham shop on Canal Street and then moved into an old shop left vacant by Rhoades Sherman and Mr. Lewis on the east side of Fayette Street.

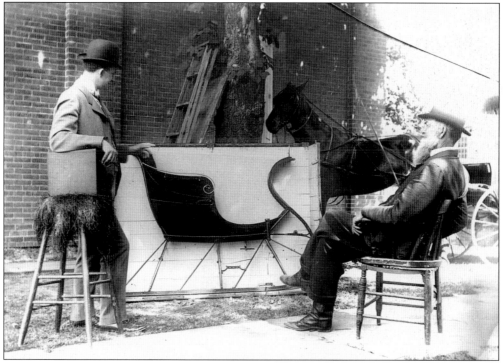

Carriage maker Calvin Seeley sits outside Ziegler's Carriage and Repairing Shop, on Market Street, in 1890. Jacob Ziegler was a carriage ironer and a blacksmith. After his return from the Civil War, he resumed business in a new brick building. After Ziegler died in 1915, his son Louis Ziegler took over the shop.

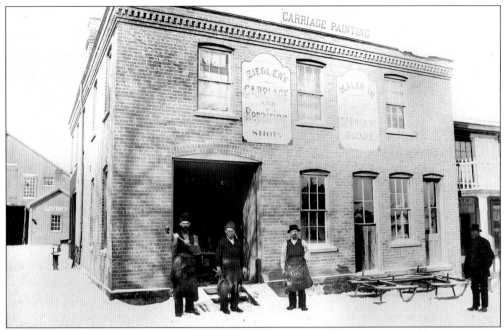

Ziegler's Carriage and Repairing Shop is pictured c. 1882 on the west side of Market Street. Standing out front are Jacob Ziegler and Charles Zifpal (believed to be the one with the sledgehammer). Behind the shop is a livery. Market Street was a busy area in the old days.

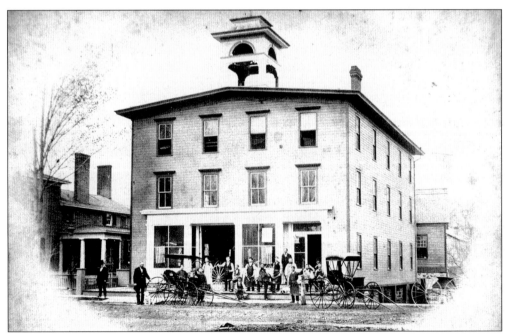

The Alanson Sherman Carriage Factory was located on the east side of Fayette Street. The shop gained a new partner and became Sherman & Crandall. Pictured in 1868, the shop made carriages and sleighs—the whole vehicle, from the wheels to the final coat of paint. The partnership also bought a share of the Powers Hotel, on the corner of Fayette and East Main Streets.

The William S. Phelps Store is located on Market Street. Originally, it was a Federal-style building, with double doors facing the Erie Canal. William Phelps purchased it in 1868 and changed the storefront to open onto Market Street. For rental purposes, he built an addition with a storefront. The family lived in this building for 108 years; the last living member was Sibyl Phelps, who died in 1976. The building had neither electricity nor running water. This picture dates from 1915, during the Fireman's Convention. Today, the store is a museum.

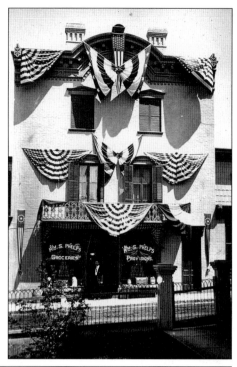

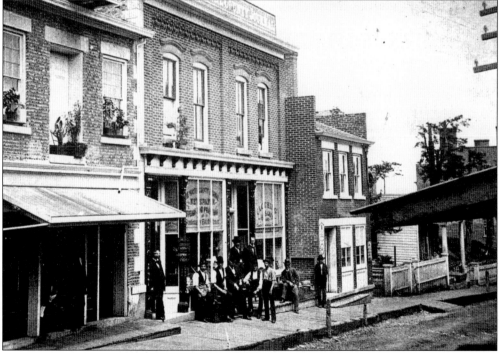

This view looks north along the west side of Market Street in 1875. The men are standing outside of the *Wayne County Journal* newspaper office. The old cobblestone building to the left still exists, and the small building next to the garages was the law office of Hiram Jerome, a great-uncle of Jenny Jerome, Lady Randolph Churchill.

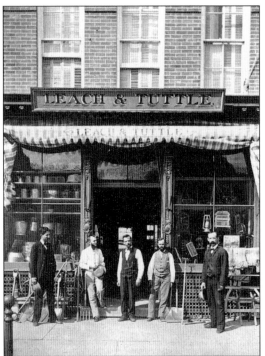

The Leach & Tuttle Hardware Store sold stoves and a Tuttle toilet with a bowl labeled Ganargua. It was located on East Main Street a few buildings up from Market Street. Standing in front of the store in 1884 are, from left to right, H. K. Comerais, a salesman from Boston; Judge S. Nelson Sawyer; J. P. Tuttle; Dave Aldrich; and J. W. Leach.

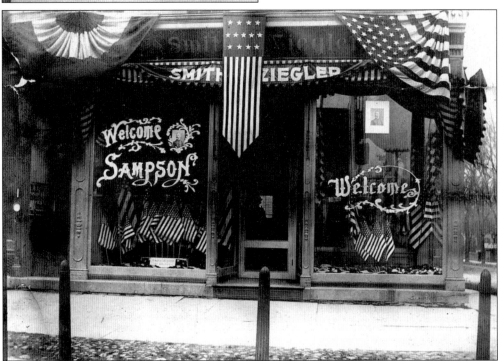

The Smith and Ziegler Store, at the corner of Cuyler and East Main Street, is decked out for Sampson Day in 1899, held in honor of Spanish-American War hero Rear Adm. William Sampson. The store sold watches, pens, fine china, jewelry, eyeglasses, and other items. Notice the cobblestone street lined with horse posts.

Patented in 1892, the Little Bonanza fanning mill was manufactured in Palmyra by the Little Bonanza Fanning Mill Company. Why buy this Little Bonanza? The company lists 38 reasons, including No. 34, "Because every machine is tested before it leaves the shop," and No. 38, "Because it absolutely does the work intended for it," which is winnowing grain.

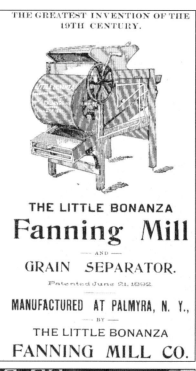

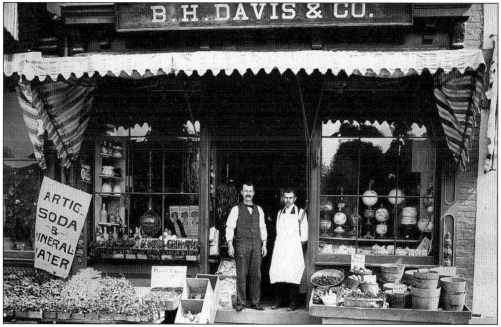

B. H. Davis & Company was a grocery and drugstore, but the storefront in 1895 shows produce, mineral water, lamps, and much more. It was located at 87 East Main Street. While in New York City, B. H. Davis met Henry Runterman, a teenage boy from Germany who could not speak a word of English. Davis brought the young man home and made him a clerk in the store. After Davis retired and his partner, Mr. Cleveland, died, Runterman, standing on the right, bought the store.

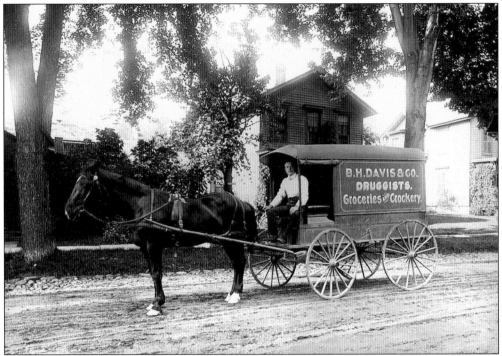

The B. H. Davis delivery wagon advertises "Druggists, Groceries, and Crockery."

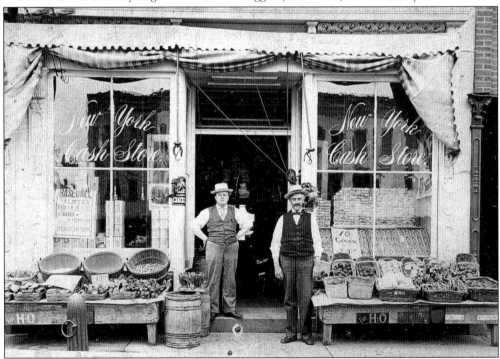

Brown's Grocery Store was located on East Main Street near the corner of William Street. The sign in the window in 1890 notes "New York Cash Store." Some stores would take credit and others would not.

The First National Bank, on the west corner of William and East Main Streets, is pictured in 1890. From left to right are J. Schuler, cashier Martin Smith, bank president Pliny T. Sexton, Sanford Van Alstine, Willard Page, and Harry Chapman.

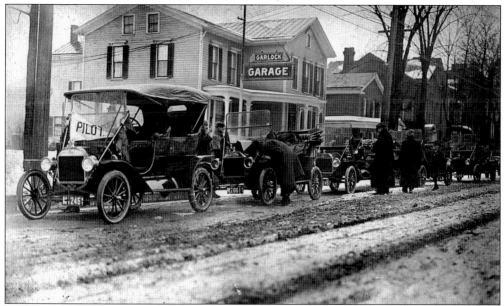

A road rally forms on East Main Street in front of the Garlock Garage and O. J. Garlock's home in 1910. Last-minute tune-ups are in order, and then the pilot vehicle is ready to go. There was very little that O. J. Garlock was not interested in. Certainly, cars were important to him. Garlock was a successful businessman but seemed always to have time for his family, his photography and other hobbies, and a trip, be it a day trip or a holiday.

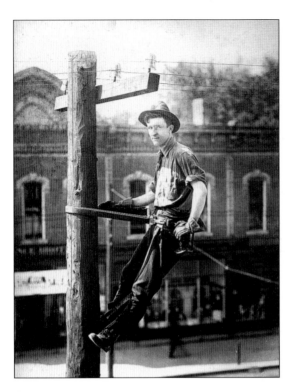

Equipped with climbing spikes and a safety belt, Jay Shear checks the insulators and wiring on one of the early electric poles on Palmyra's East Main Street in 1910.

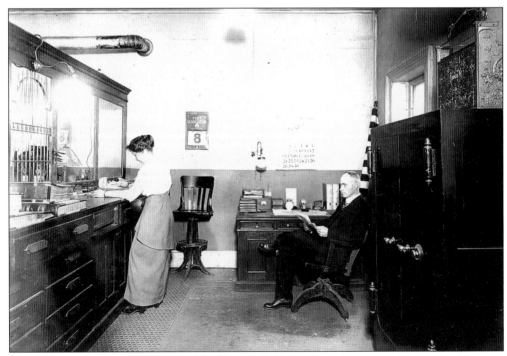

This 1915 view shows the interior of the New York State Gas and Electric office in the Clemons Block. Hannah Sanders stands at the counter as Mr. Clark reviews some papers. The gas and electric company maintained a Palmyra office, where bills could be paid, until the mid-1970s.

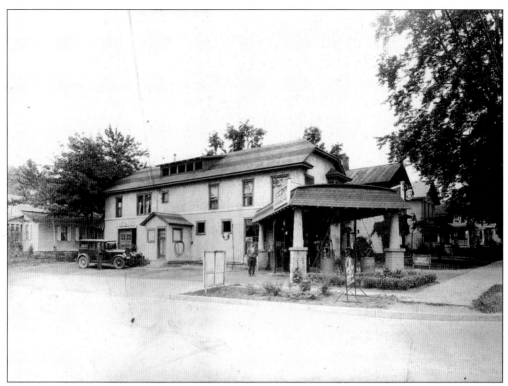

This full-service gas station was built and owned by Reeves Parker in 1923. Located at the corner of Mill and East Main Streets, the station sold Socony products. The first Democratic Schoolhouse was built on this site. Gas stations were popular in the east end of the village, and today, they still monopolize the area.

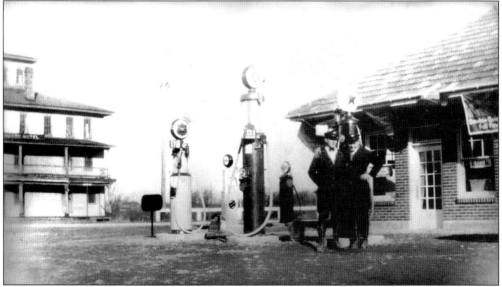

Neale's Gas Station was located on Canal Street near the Exchange Hotel (left background). The station carried Texaco gasoline, which was hand-pumped into the glass tube before it went into the automobile. The gasoline cost 18¢ or 14¢ a gallon. One of the men is Reggie Neale.

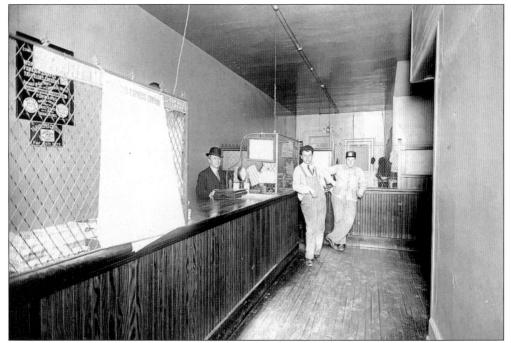

The Western Union office stood at 212 East Main Street near the Republican flagpole in 1920. Betty Monroe was in charge of the office, in which American Express Travelers Cheques were sold and money and messages were wired to faraway places. In later years, Fred Witt bought the property and opened it as a barbershop.

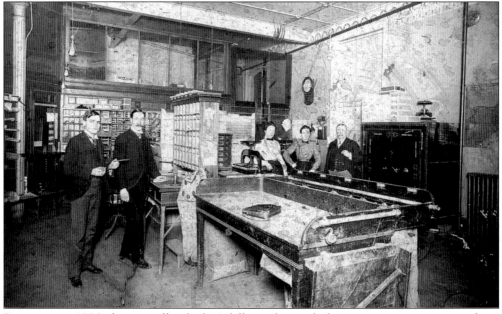

Beginning in 1806, the post office had 10 different homes before opening in its current place. The one shown here in 1899 is in the Palmyra Village Hall. Postmaster Fred Clemons stands in the back right. With him are A. E. Williamson, assistant postmaster, and clerks Albert Quaife, M. Burns, and M. Taylor.

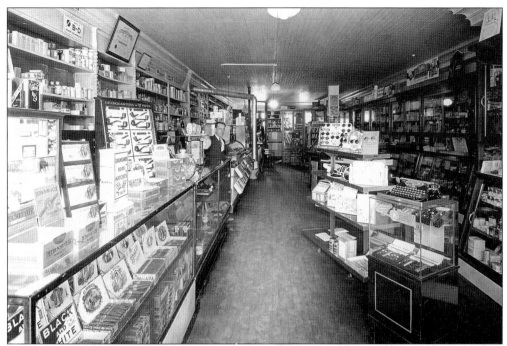

Briggs Drug Store was in business for many years on the south side of East Main Street. Once the Rushmore Drug Store, David Briggs bought this building c. 1923. A typical drugstore, Briggs sold tobacco products, school supplies, and ice-cream sundaes. The person by the counter in this 1935 view is a man identified as Fred Salem. Briggs Drug Store closed in the late 1970s.

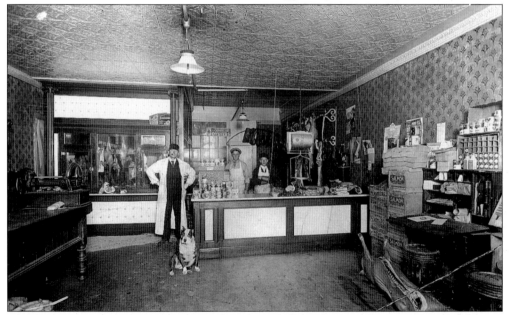

The Darling Meat Market sold meat and poultry of all kinds, from the carcass on the floor to the chickens and turkeys hanging in the back cooler. The store was located on the northeast corner of William and East Main Streets. Pictured in 1880 are, from left to right, William Darling, William Ray, and John Rush.

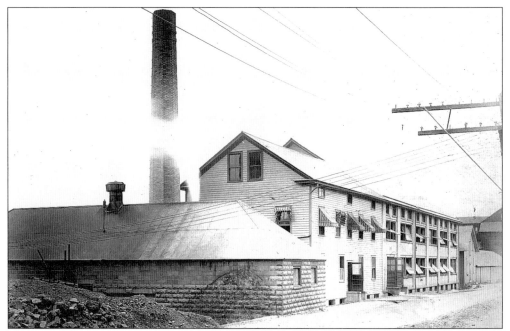

The Crandall Packing Company was founded by George Crandall in 1887. Pictured in 1900, the plant was located on Canal Street near Church Street. Crandall attracted investors Dr. W. J. Hennessey, B. H. Davis, A. P. Marshall, J. Coates, C. North, and J. Cleveland. After a fire, the factory was rebuilt. When business dropped off, Hennessey sold his shares to O. J. Garlock. Upon discovering what Hennessey had done, the other partners did the same.

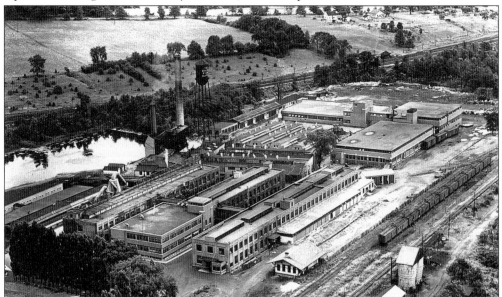

The original factory of the Garlock Packing Company was located on Prospect Drive. O. J. Garlock invented packing using rubber and began by selling it locally. He found partners Crandall and Nichols in 1884 and built up the manufacturing business. Leaving Crandall, Garlock and Nichols partnered with F. W. Griffith. This plant, shown in 1947, is located off Division Street north of the canal.

Seven

THERE WAS ALWAYS A CAUSE

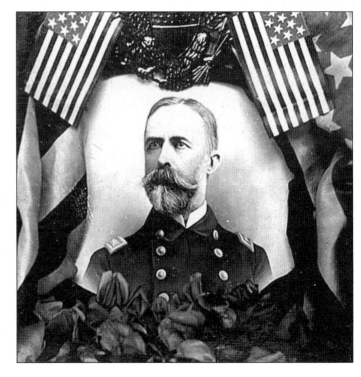

William Sampson entered the U.S. Naval Academy by congressional appointment and rose to the top of his class. During the Civil War, he was assigned to a frigate. As rear admiral, Sampson lead the largest U.S. fleet of ships ever commissioned. Sampson is credited with the success of the Battle of Santiago and the end of the conflict. A ship's cannon was sent on permanent loan to the village of Palmyra in honor of this hero. This picture dates from 1898.

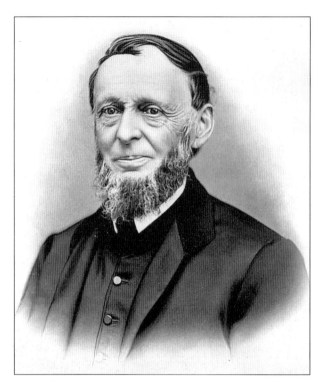

Originally from Auburn, Pliny Sexton made surveying compasses. He came to Palmyra in the early 1800s and opened a store. He worked with Rev. Horace Eaton, who initiated his abolitionist activities in Palmyra in 1849. Sexton's East Main Street home is listed on the Freedom Trail as an Underground Railroad site. The father of Pliny T. Sexton, he worked at the First National Bank. This picture dates from 1860.

Rev. Horace Eaton, D.D., was the pastor of the Western Presbyterian Church from 1849 to 1879. As an abolitionist before the Civil War, he assisted slaves through western New York State on their way to Canada. He hid them by the dark of night in the church office near the old town clock. He also took his fight to Congress. Another of Eaton's causes was temperance.

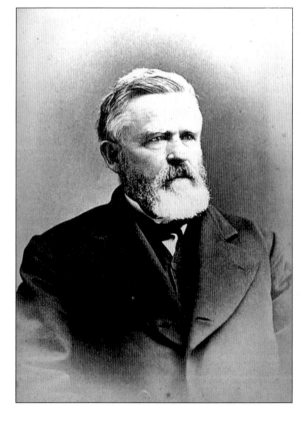

The 33rd New York Volunteers were recruited by Col. Joseph Corning, John Corning, and Captain Draime and sent to Elmira. Shown seated in this photograph is, from left to right, John Corning, Captain Draime, and Captain White. Colonel Corning is standing. The Corning brothers and Draime fought from 1861 to 1863 in the Civil War. Joseph Corning was a lawyer, and John Corning opened a grocery store.

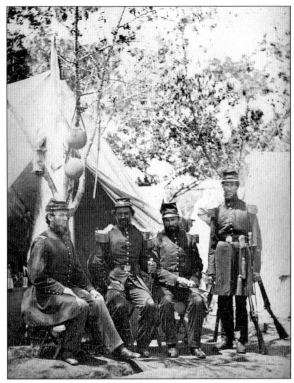

Dr. Samuel Sabin was a doctor in the Civil War who is said to have known Abraham Lincoln personally. The notes accompanying this c. 1863 photograph state that Sabin died in the Martinburg, Virginia, hospital in 1865.

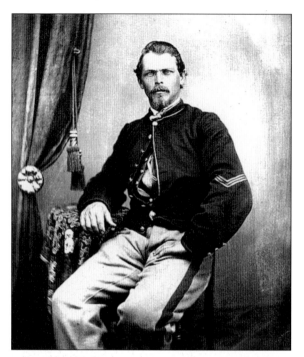

This 1863 photograph shows Jacob Ziegler in his uniform as a member of the 8th New York Cavalry. Family notes on the back of the image say that Ziegler received the flag of truce when Gen. Robert E. Lee surrendered at Appomattox.

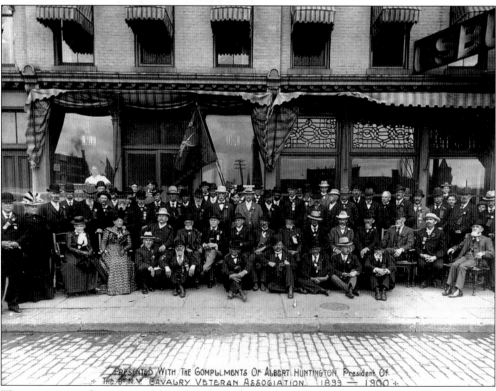

This is a picture of a reunion of the 8th New York Cavalry Veteran Association held in 1899–1900, compliments of Albert Huntington, association president. Is Jacob Ziegler in the group?

Pictured in 1863 is Lt. Winfield Scott Chase, who fought in the Civil War. The son of Dr. Durfee Chase, he had three daughters: Ella, Susie, and Mina Chase. He is reported to have known Abraham Lincoln personally.

Six Civil War veterans pose for a portrait in 1908. W. W. Williamson (far left) was the village president in 1891. (Photograph by George Elton.)

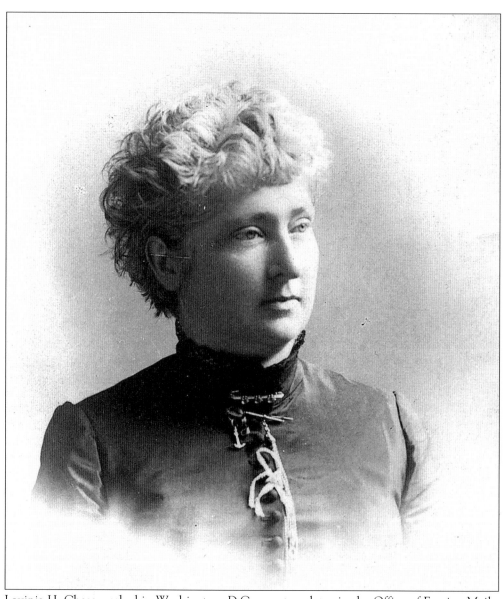

Lavinia H. Chase worked in Washington, D.C., as a translator in the Office of Foreign Mails. The daughter of Dr. Durfee Chase and sister of Winfield Scott Chase, she visited the sick and lonely Civil War soldiers at Washington area hospitals. She spoke before Congress on removing the "grog shops" close to the grounds and was successful. Weekly, she arranged to have music and speakers at a hall where enlisted men came, and she invited the officers, gaining their total support. During the 1898 war, she began a club to benefit soldiers, which grew into the Soldiers', Sailors', and Marines' Club. She arranged it so that women from Palmyra, such as Anna Draime, were the house matrons, and she got the Officers Wives from the Navy and Army (Women's League) involved in duties. This picture was taken c. 1890.

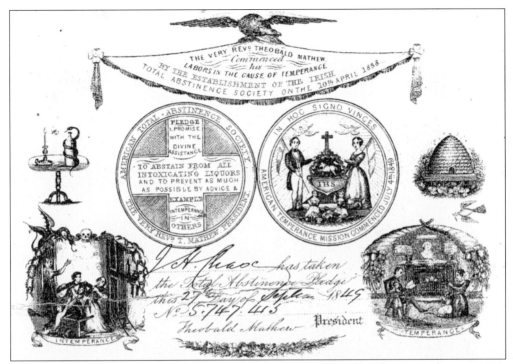

This temperance pledge, "Total Abstinence No. 5,757,415," was taken by L. H. Chase in 1849. According to an article by Mina Dadmun, Lavinia H. Chase was sitting with the soldiers at a meal during one of her weekly events when Gen. Philip Sheridan asked her, "Now when are you going to sit down and have a talk over that glass of lager, and when am I going to convert you?" She replied that she would try and convert him.

Henry Hilborn was brought to Palmyra in 1921 to stop speeders and to keep law and order. He started the Wayne-Ontario County Motorcycle Patrol for catching thieves and for detecting fires on large farms. He is pictured in 1923, after he became police chief. He regularly fought bootleggers, who were very active in Palmyra. At the age of 31, he was reportedly poisoned by the bootleggers and died that same year.

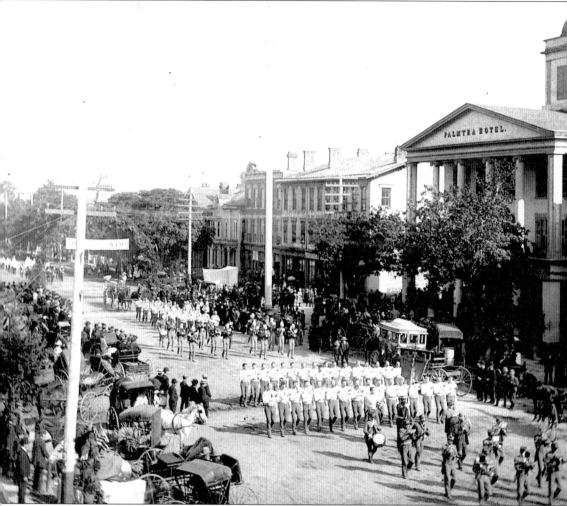

Shown is the Firemen's Convention and Parade of September 11, 1885, on East Main Street in front of the Palmyra Hotel. Officers of the Steamer & Hose Company No. 1 in 1885–1886 were A. W. Carney, president; Ed Reeves, vice president; Dr. Hennessey, secretary; E. I. Bingham, treasurer; John Bill, steward; Ed Anderson, steamer foreman; Andrew Powers, assistant; Antonio Seeley, hose foreman; George Barron, assistant; and John Coates, drillmaster.

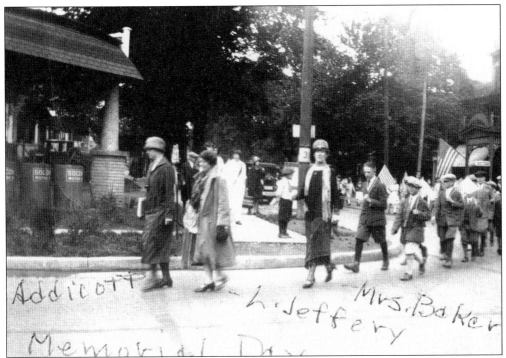

Suffragettes were not foreign to Palmyra, and the fight for right, no matter what the cause, was always a reason to dress up, carry flags, and have a parade. Whether the audience was large or small, just to be in America where such opinions can be voiced something to celebrate. This picture was taken c. 1919.

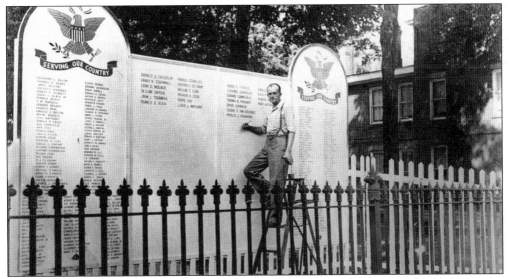

Names were added to these panels, standing in the Village Park, on a regular basis as more soldiers served in World War II. Over 400 names were listed on these boards as "Serving Our Country." The James R. Hickey Post 120 and the Veterans of Foreign Wars Post 6778 had these boards redone to hang in the village hall. In peacetime and in wartime, Palmyra continues to honor all of its dedicated military personal, from World War I through the war in Iraq.

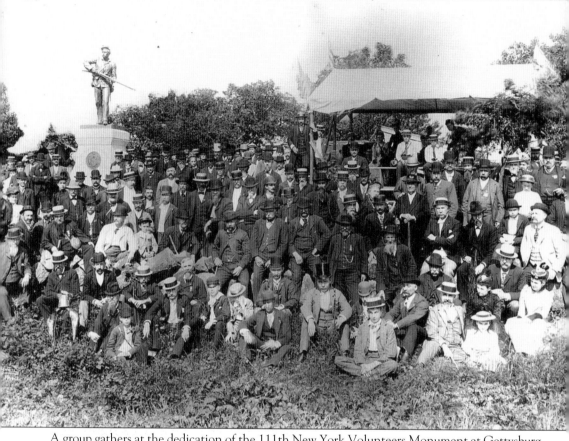

A group gathers at the dedication of the 111th New York Volunteers Monument at Gettysburg, Pennsylvania, in 1891. Hundreds of men, women, and children attended this ceremony recognizing the dedication and honor of the soldiers who gave life and limb in the fight for the Union. Many men from the village of Palmyra fought in the 111th New York Volunteers, and many of them did not return home. At the Palmyra Board of Trustees meeting held on March 20, 1867, at the office of Peddie & Finley, Dr. Francis Brown offered a resolution to allow the "ladies of the village" to place tablets in the lower hall to commemorate the town's fallen soldiers. To assist in making arrangements for installation, a committee consisting of Dr. Brown, a Mr. Foster, and a Mr. Myrick was formed.

Eight
THE IMPORTANCE OF ORGANIZATIONS

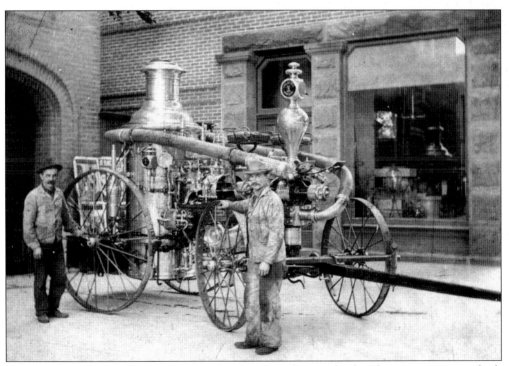

Two men pose by an old steam wagon that has forged iron wheels. The steam wagon, which dates from the late 1800s, was a proud holding of the Palmyra Steam and Hose Company. The men are identified on the back of this 1949 photograph as R. J. Liling and Chief Cullip. They are standing in front of the 1868 Palmyra Village Hall, which housed the fire department until the 1980s.

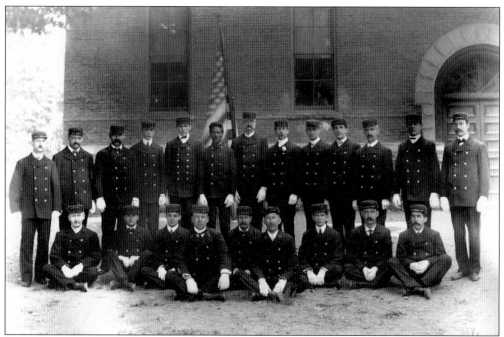

Pictured are members of the Sexton Hydrant and Hose Company in 1903. From left to right are the following: (first row) hose foreman H. P. Stetson and foreman W. H. Dennis; (second row) ? Haring, ? Dibble, F. Hislop, ? Haddleton, ? Poyzer, ? Jeffery, and ? Balcem; (third row) ? Lyon, ? Spanginburgh, ? Tiffany, ? Mitchell, ? Cable, ? Baxter, ? Wellman, ? Cady, B. Hislop, ? Chase, ? Wood, ? Mitchell, and ? Calhoun. (Photograph by George Elton.)

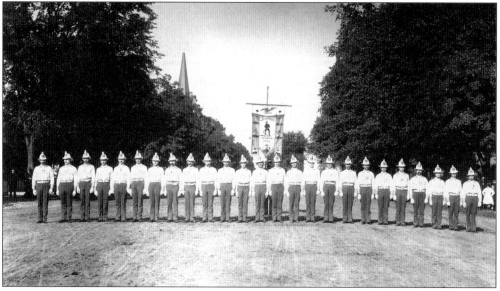

The fire department won second place for competition drill in 1890. Notice the dollar sign on their shirts.

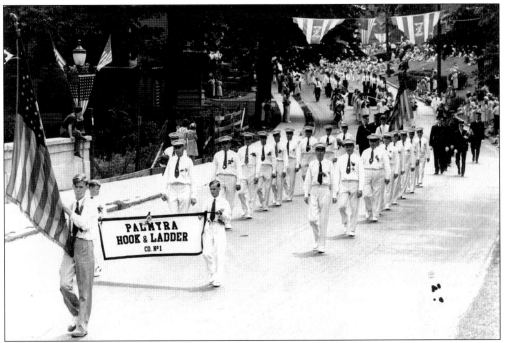

Members of the Palmyra Hook and Ladder Company No. 1 attend a fire department convention in 1900.

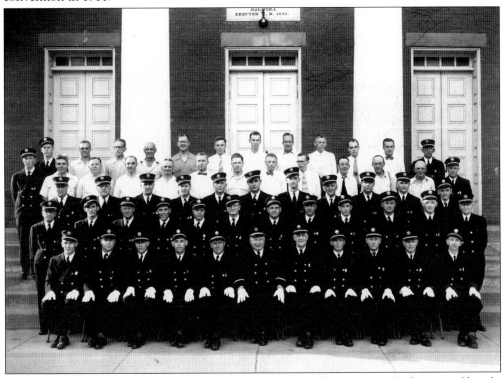

Members of the Palmyra Fire Department pose in front of the Western Presbyterian Church, on East Main Street, in 1952.

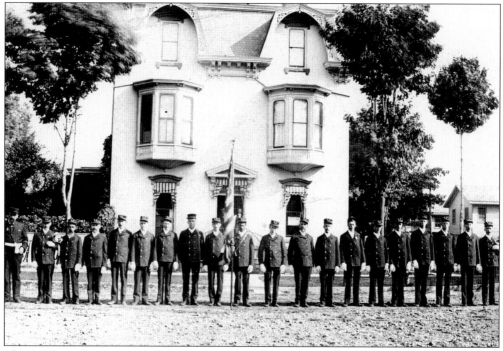

This 1899 picture shows the Palmyra Steam and Hose Company in front of the First National Bank, on the corner of William and East Main Streets.

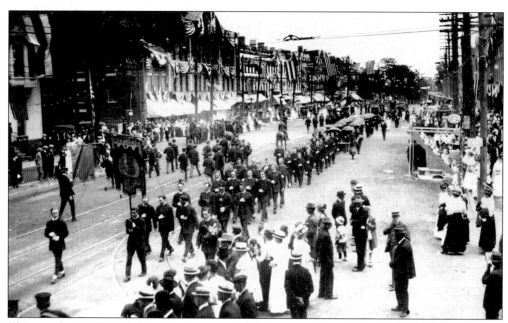

This parade in 1900 is believed to be part of the Sampson Day celebration.

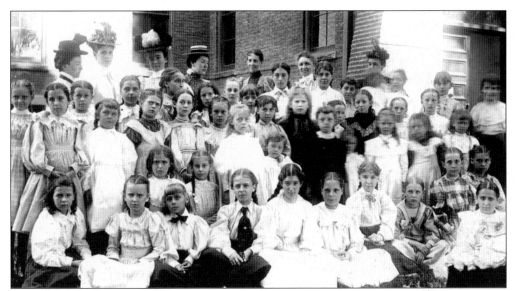

Members of the King's Daughters' sewing class pose in front of the Palmyra Union Classical School in 1888.

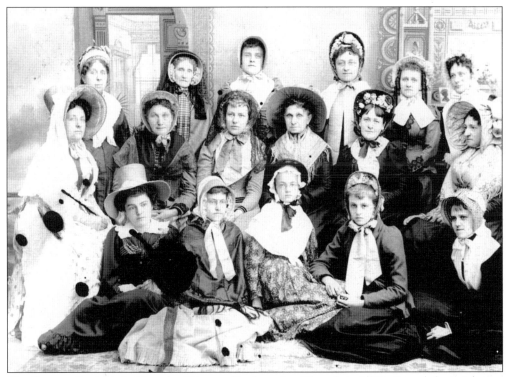

The Bonnet Social is held at the Western Presbyterian Church in 1892. From left to right are the following: (first row) Clara Riggs, Fannie Yoemans, Grace Williams, Grace Beal, and Nellie Clark; (second row) Julia Hall, ? Davenport, Lizzie Luiley, Mrs. William Kent, ? Jenner, and Marnie Hill; (third row) Sarah Hall, Mrs. Joseph Rogers, Kate Jenner, Anna Jackson, Mrs. H. R. Durfee, and Mrs. Whitney.

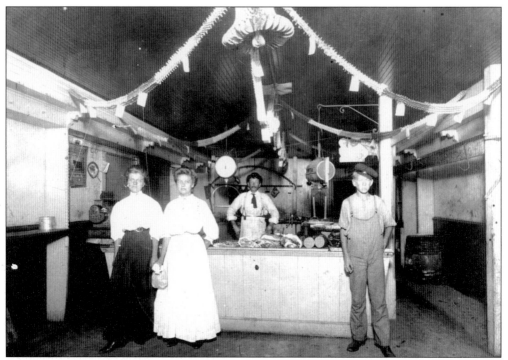

This picture shows a meat stand at the Wayne County Fair c. 1890.

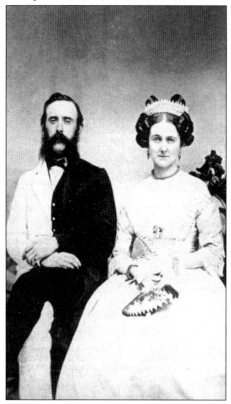

Mr. and Mrs. Charles Butterfield Bowman are dressed for the fancy dress party held on January 18, 1867, at the Palmyra Union Classical School to benefit the freedmen. Notice the clothing Bowman is wearing, showing his support for the recent fight for freedom—thus freedmen.

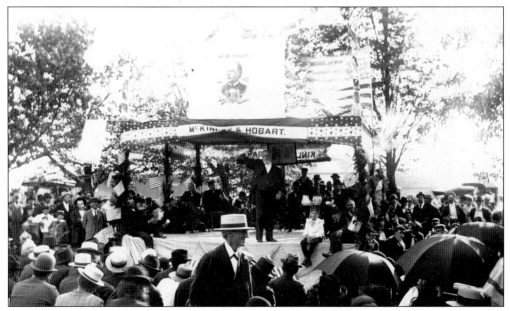

The Abraham Lincoln True Blues No. 29 hold an Entertainment and Box Social c. 1892. The message at the bottom right reads, "Ladies Please Provide." Would it be the box lunches?

At this July 4, 1900, Republican rally, Sen. S. E. Payne speaks for the presidential campaign of William McKinley.

Members of the Palmyra Nurses' Club pose c. 1950. From left to right are the following: (first row) Barbara Bailey, Hilda McGuire, Ollie Hammond, Helen Wilson, and Sid Fisher; (second row) Esther Mierke, Arlene Fisher, Ann Brown, Dorothy Chittenden, and Lucille Perrez; (third row) Shirley Luppold and Thelma Luppold (Ritz); (fourth row) Betty Morhouse, Marge Keith, Fanny Darling, Adie DeVuyst, Sara DeNagle, and Sophie Ziegler.

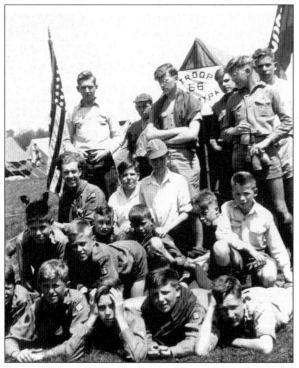

Members of Troop 66 are shown at a Boy Scout campout c. 1950. Still very active today, Troop 66 participates in the Wayne County Fair and the Canal Town Days events.

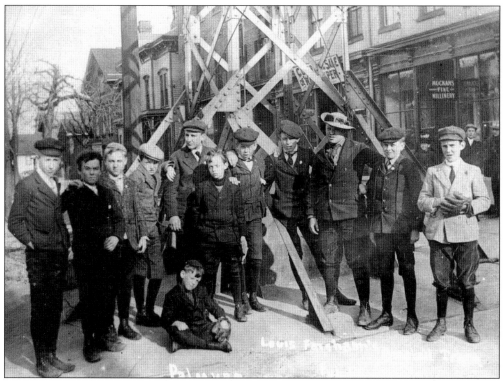

The Farnham baseball team gathers by the flagpole on the corner of Fayette Street and East Main Street in 1907. The team represented Louis Farnham's Store, which was to the west, down the East Main Street Block. (Courtesy of a private collection.)

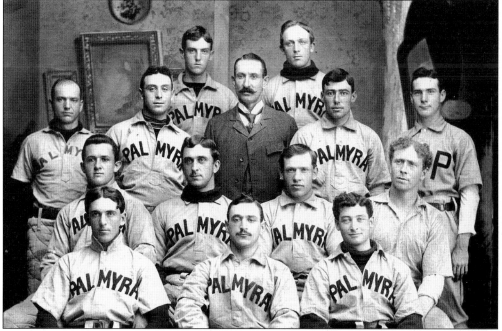

A Palmyra baseball team poses for a photograph in 1897. (Photograph by George Elton.)

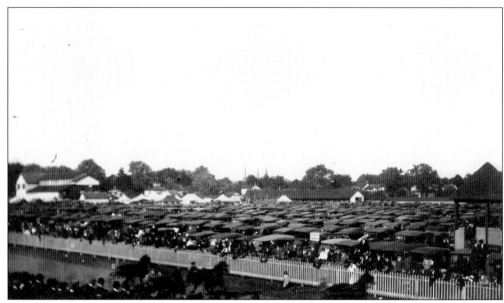

Sulky racing at the Wayne County Fair was a big draw. Notice how full the parking lot is in 1924. Floral Hall, dating from 1856, is in the back left and is still standing today. Three church steeples are visible in the center distance.

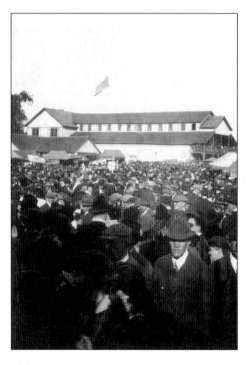

The Wayne County Fair Association Board is in charge of the fair, which is held a full six days in August every year. The fairgrounds are located in the center of the village of Palmyra between West Jackson, Birdsall Parkway, West Foster, and Stafford Streets. Shown is the elbow-to-elbow crowd c. 1940, with a closer view of Floral Hall.

Nine
THE "QUEEN" STILL HAS HER MAJESTY

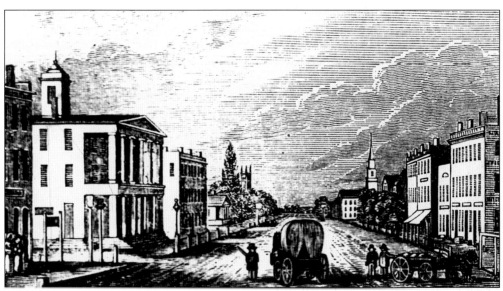

Looking west toward two churches, this view shows Main Street, quiet except for the couple of wagons, in the 1840s. Visible are the Powers Hotel (or Eagle Hotel, depending on the year), the north and south sides of Main Street, and some small wooden buildings.

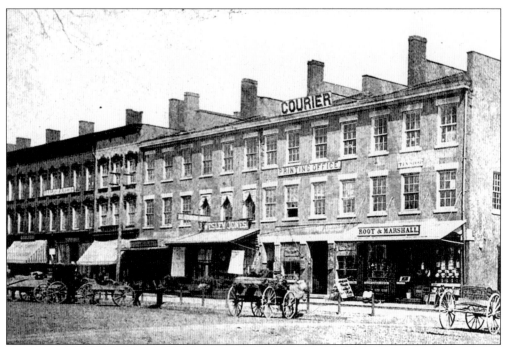

This is a view of the north side of East Main Street at the corner of Market Street c. 1875. The Root and Marshall Store is on the corner, with the "Tin Shop" sign on the front. West of that is the *Palmyra Courier* building, with a printing office sign under the third-floor windows. Farther west is a storefront with the sign "Wesley Jones." The flat roofs and old chimneys are unique to this period.

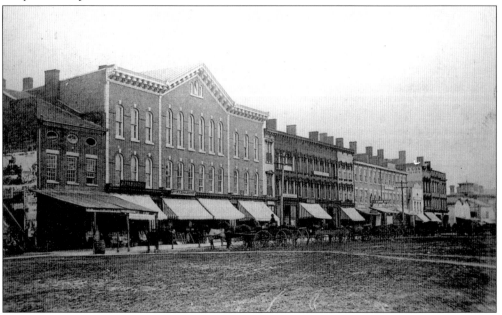

Looking east is another view of the north side of East Main Street c. 1875. Notice the awnings shading the store windows and the horse-drawn wagons picking up supplies. (Photograph by A. C. Hopkins of Palmyra.)

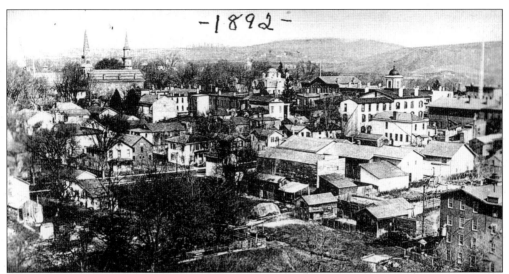

This 1892 view was taken from Prospect Hill, formerly called Holmes Mountain. Shown are the old Garlock Packing Company (lower right), the old Palmyra Hotel (Powers or Eagle), the Republican flagpole, the Palmyra Village Hall (upper left), and three church steeples.

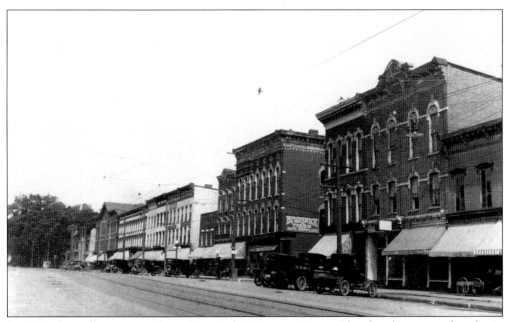

In 1906, the trolley came to town. Notice the wires crossing overhead and two sets of tracks on East Main Street. The maiden run was taken by the crew from the Garlock Packing Company. The old trucks appear to be coexisting with the trolleys.

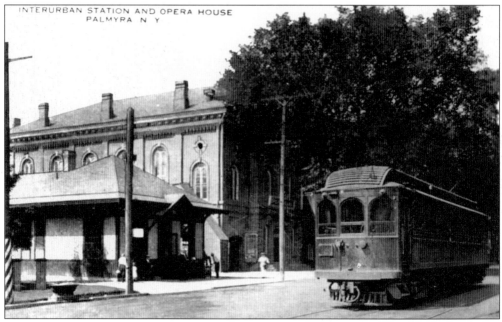

The Rochester-Syracuse Trolley heads east from Rochester through all the canal communities in Wayne County in the early 1900s. The trolley station is the small building on the left, with the Palmyra Village Hall and Opera House on its west.

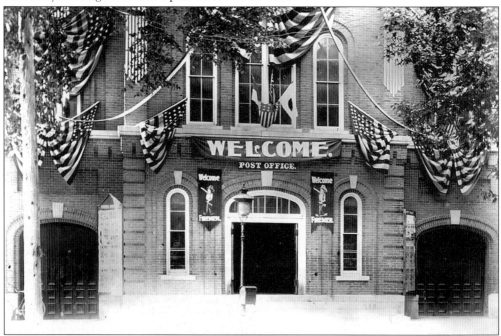

Built in 1868, the Palmyra Village Hall and Opera House (upstairs) is pictured in 1915, the year the Firemen's Convention was being held in Palmyra. In 1927, the post office moved across the street to a larger space in the O. J. Garlock building. Today, the village hall remains as it was but without the opera house. The large doors have been replaced with windows, and the giant staircase leads to unused space upstairs.

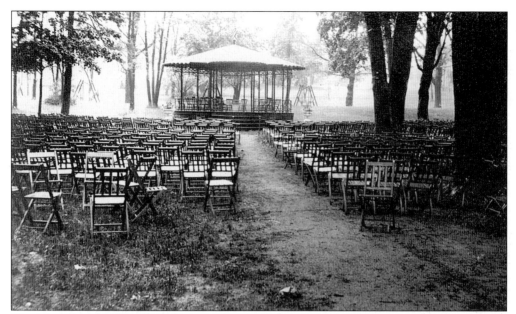

The Main Street Village Park is pictured in 1907. Its unique bandstand roof was rebuilt about five times before it became acceptable to Pliny T. Sexton, who donated the park. In the summertime, concerts and activities were held weekly. In the early days, chairs were set up for the audience. Today, movies and concerts are still held in the park, but people have to bring their own chairs.

Shown in the 1950s is the restaurant known as the Garlock House since the late 1940s. People came from miles around to visit this old home that once belonged to O. J. Garlock and, earlier, to some of Palmyra's other first families. Today, the restaurant is called the Historic Garlock House.

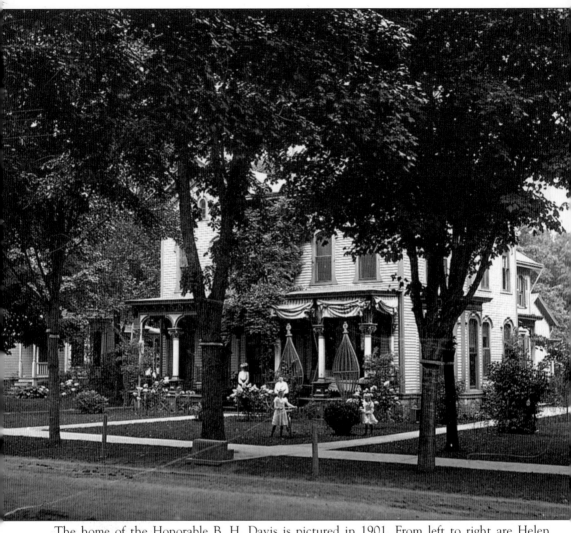
The home of the Honorable B. H. Davis is pictured in 1901. From left to right are Helen Webster, Margaret Webster, Cora Davis Webster, and the wife of B. H. Davis. The house is one of the beautifully preserved homes in Palmyra.

The row buildings on the east end of Main Street past Market Street and before Clinton Street still look the same today as they did in the 1890s. This picture was taken in 1940.

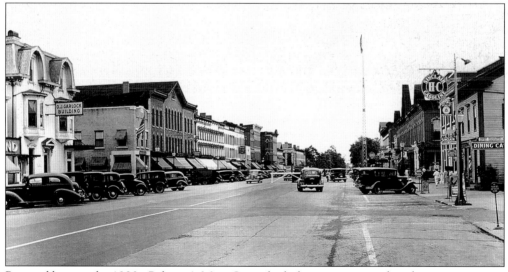

Pictured here in the 1930s, Palmyra's Main Street looks busy no matter what the transportation method—wagons or Toledo steamers or automobiles. At the junction of two major New York State highways, Routes 21 and 31, Palmyra is a central traffic area for those coming from work in the big city and those going to either Lake Ontario or Canandaigua Lake. To the motorist passing through or the visitor stopping by, the skyline of the village looks much the same today as it did in 1880.

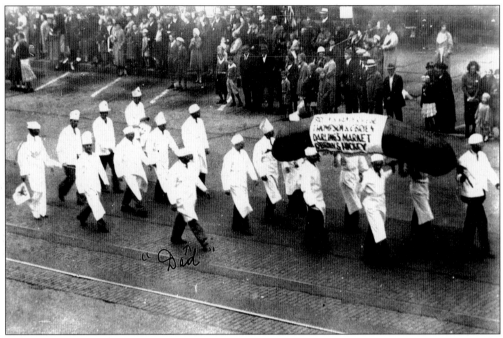

Shown is the meat market contingent from a Palmyra parade in 1933. Just right for a parade, Palmyra's Main Street draws unique organizations during the warmer months. Events happen here at least three times a year: the Memorial Day parade in May, the Firemen's Parade in August, and the Canal Town Days Parade in September.

Founded in 1789, Palmyra is an original community that, through the years, has grown and prospered. It is pictured here c. 1921. Its citizens have singular thoughts and ideas, but they all share the town's vibrant history as the "Queen of Canal Towns."